TEXAS

TROUBADOURS

NUMBER TWENTY

Jack and Doris Smothers Series in Texas History, Life, and Culture

TEXAS
TROUBADOURS

texas singer songwriters

Steve Harris

Foreword by Kinky Friedman

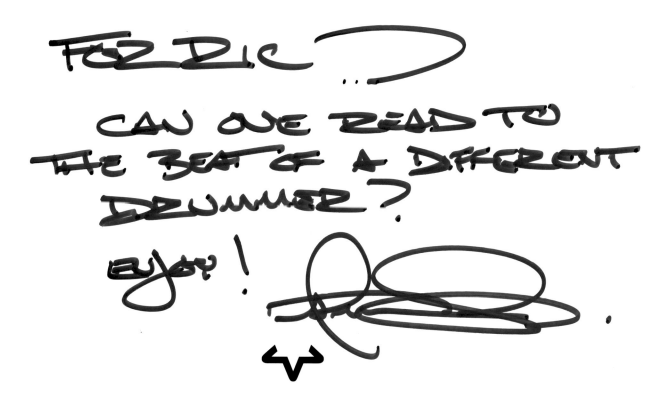

FOR DIC...
CAN ONE READ TO
THE BEAT OF A DIFFERENT
DRUMMER?
ENJOY!

UNIVERSITY OF TEXAS PRESS

AUSTIN

Publication of this work was made possible in part by
support from the J. E. Smothers, Sr., Memorial Foundation and
the National Endowment for the Humanities.

Requests for permission to reproduce material from this work should be sent to:
Permissions
University of Texas Press
P.O. Box 7819
Austin, TX 78713-7819
www.utexas.edu/utpress/about/bpermission.html

The paper used in this book meets the minimum requirements of ANSI/NISO
Z39.48-1992 (R1997) (Permanence of Paper).

Library of Congress Cataloging-in-Publication Data
Harris, Steve, 1960 –
Texas troubadours / Steve Harris ; foreword by Kinky Friedman. — 1st ed.
p. cm. — (Jack and Doris Smothers series in Texas history,
life, and culture ; no. 20)
ISBN-13: 978-0-292-71324-6 (cloth : alk. paper)
ISBN-10: 0-292-71324-X (cloth : alk. paper)
1. Country musicians — Texas — Portraits. I. Title. II. Series.
ML87.H2435 2007
781.642'0922764 — dc22
[B]
2006017296

For the farmers and the beekeepers
and for Gisele, the woman with the dogs
who opened the door to many things.

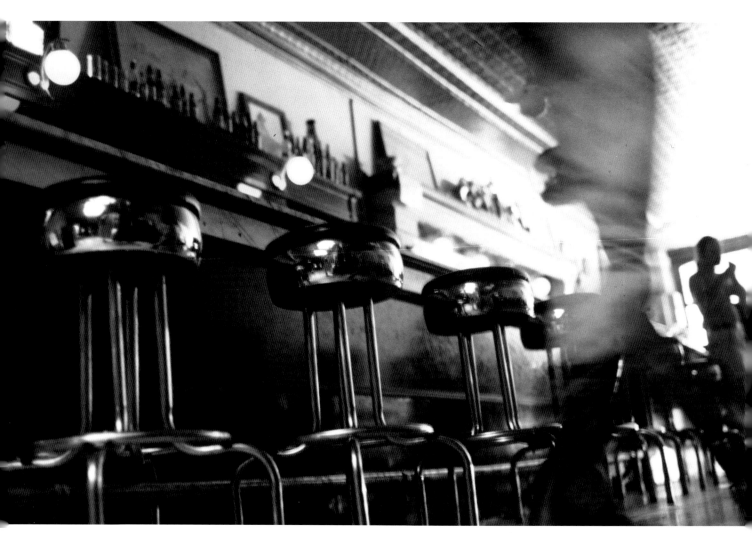

"When someone takes something simple and makes it complex, we call that person an intellectual. When someone takes something complex and makes it simple, we call that person an artist."

FOREWORD

Singer-songwriters have always been the long-suffering, little-celebrated spiritual stepchildren of the bigger, more commercial country music stars. As Barry Antelope says, they write the songs. Not only that, they usually perform the songs better than anyone else. This should not be terribly surprising. The songs, after all, have been created by hand and heart from the ragged-but-righteous, weather-beaten fabric of the singer-songwriter's soul.

Needless to say, these kinds of critters are often lonesome, ornery, and mean, not to mention almost impossible to confront or capture. It is no small achievement that Steve Harris was able to corral so many of them into this book. Singer-songwriters, as a rule, do not like to be photographed. They believe that every snapshot takes away a little piece of the possibility that they might become an Indian when they grow up. This notion, indubitably, made the project even more challenging for the intrepid Steve Harris.

Harris, it should be noted, has an extremely accurate bullshit meter as well as a fine photographic eye. Everyone included in *Texas Troubadours*, with the possible exception of myself, parked his or her ego at the door and paid dues in full. I, of course, got an Israeli discount. All of us, however, have known the road, the cheap motels, the beer joints and half-filled houses, the days when our autographs were bouncing, the long nights of pain and beauty beyond words and music. All of us have cried on the shoulder of the highway.

When someone takes something simple and makes it complex, we call that person an intellectual. When someone takes something complex and makes it simple, we call that person an artist. Steve Harris has persuaded the participants of this project to condense their very essence, for better or worse, into one statement. Some of these comments are wise and witty, some are joyful and filled with irritating gentile optimism, and some, like my own, are jaundiced, cynical, and bitter. Mercifully, they are all rather brief.

So now that you've got Steve Harris's *Texas Troubadours*, you can peruse the photo gallery, scrutinize the commentary, and then go out and buy the music. Better yet, hear it live. You can't go wrong with the artists in this book. Sorry, Barry Antelope did not make the cut.

KINKY FRIEDMAN

INTRODUCTION

BY STEVE HARRIS

I've been a fan of Texas music for a long time, and have been documenting live shows since the early 1980s. As the house photographer for many years at Houston's infamous Rockefeller's Nightclub, I had access to every musician who played that stage. Shooting live and backstage left me with a very cool collection of black-and-white images that evolved into a formidable body of work.

The year before Townes Van Zandt passed, I spent a memorable evening photographing a solo Townes with a full house. I processed the film the next day and watched the soulful images develop before me. That was the last time I saw Townes play. Not long after Townes, the master, left us, Texas lost another piece of its history with the passing of Mr. Doug Sahm, and I realized that someone needed to document the visual existence of these amazing singer-songwriter artists. I did some research and discovered that nothing existed with the scope that I envisioned.

Next I had to figure out exactly how to approach this daunting task. Obviously some trial and error and planning were required, but armed with a bit of patience and my 4 x 5 camera I set out on a labor of love that would end up spanning almost six years.

No sponsorships, no free film, nada. Only a small hope that perhaps one day I might be able to actually turn this project into a book that would serve not only as a visual record of sorts, but also as a "who's who" of the world of Texas singer-songwriters.

My focus was to shoot tight, intimate portraits and have the artists hand-write quotes about anything they wished. With these, I would be able to give a two-page spread to each artist, making for a visually strong layout.

For obvious reasons, my initial instinct was to try and stay away from the musicians' management as much as possible. I started with those musicians I knew, and from the start, the response was overwhelming. Everyone was thrilled to be a part of such a project and accepted willingly.

As the project moved forward, I began keeping a 5 x 7 spiral-bound sketchbook, placing my favorite image from each artist's shoot on the right-hand page, and their quote on the left. This format was an early iteration of the vision that would eventually guide the book to completion. As I continued with the project, each artist would read the other quotes and have to outwit their friends, trying to be more profound or funny. It was fun to see their reactions and hear what they had to say about their buddys' writing.

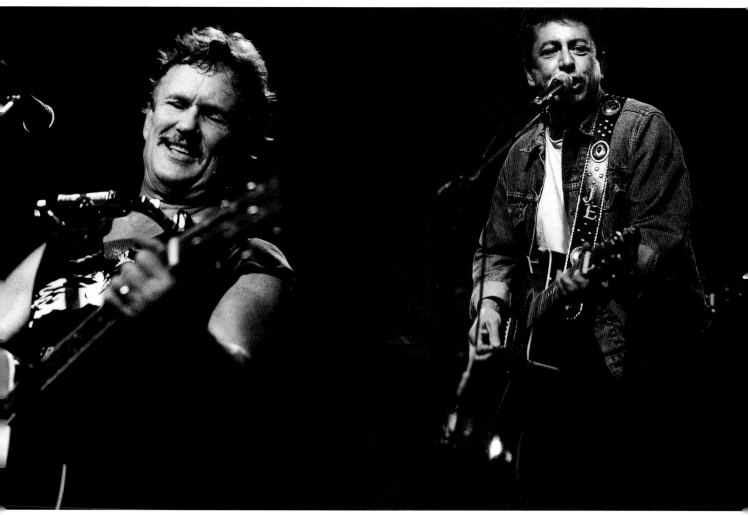

"My focus was to shoot tight, intimate portraits and have the artists hand-write quotes about anything they wished."

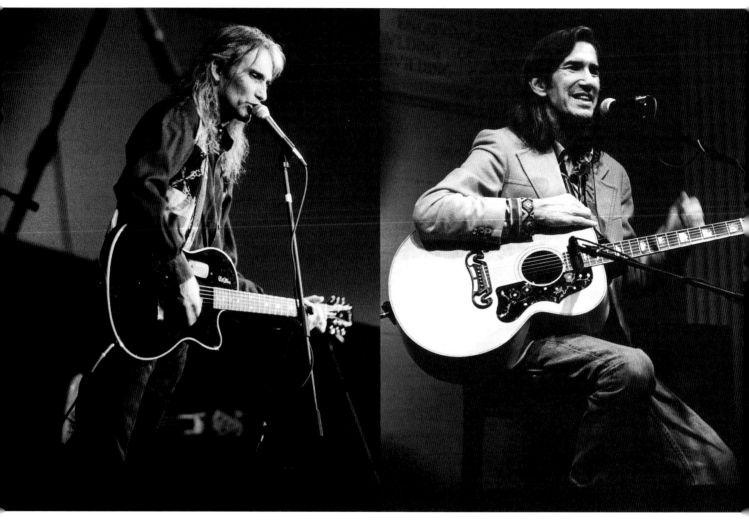

"I guess that for someone working on a follow-up record to his first 1970s release, a few years for a quote is right in line with the creative pace."

Along the way, I've sometimes had to chase down a quote long after making the corresponding image . . . all because someone or other wasn't feeling the "writing groove" at the time. For instance, Willis Alan Ramsey. I was able to shoot his portrait relatively quickly, but it took a few years to get a quote out of him; I guess that for someone working on a follow-up record to his first 1970s release, a few years for a quote is right in line with the creative pace.

This entire project has been everything I imagined. I was skeptical at first, wondering exactly how to approach the artists, but I finally decided to let the moment delegate the approach to each portrait, and that's how it has gone. I may have had to travel to Terlingua and beyond to get the images, but that's just part of a project of this nature. Looking back and reflecting on the creative process of the project as a whole, I am reminded of the joy that the successive portraits brought me, as each took me a step closer to my goal.

I've given the title "Honorary Texan" to Dave Alvin because, well . . . he deserves it. Dave goes back quite a way with his songwriting, and his musical style stretches back to early R & B and blues and then blends its way through rockabilly, swing, and into storytelling. His music combines all of the flavors that point to Texas. He conjures the Western swing of Hank Williams, then rolls right into the Delta blues, and blends it all together to bring a sound that sounds Texan, but somehow finds its way here out of California.

It took quite a bit of persistence to get to a lot of the artists in this book, as it should have. But once I was able to show them the project, I usually had their undivided attention. I'm sure that I haven't pleased everyone, but I think I've covered a great portion of what is considered Texas troubadour music, which brings to mind a fond memory or two. Early on in the project, I was preparing to shoot Ray Wylie Hubbard for his *Eternal and Lowdown* CD. After contacting the Hubbards, they invited me to spend a few days at their Hill Country home as well. What a treat to be invited into someone's home as a stranger, and leave as a friend! It took more than a year to finally get Alejandro Escovedo to look at the project, but once I arrived at his home, I was welcomed as a friend. Later, Alejandro extended an open invitation to come by any time I was in the area.

It's nice to know that these kinds of encounters can still happen. I shouldn't be surprised though . . . after all, it is Texas.

Billy Joe Shaver

"Simplicity don't need to be greased."

July 28, 2001

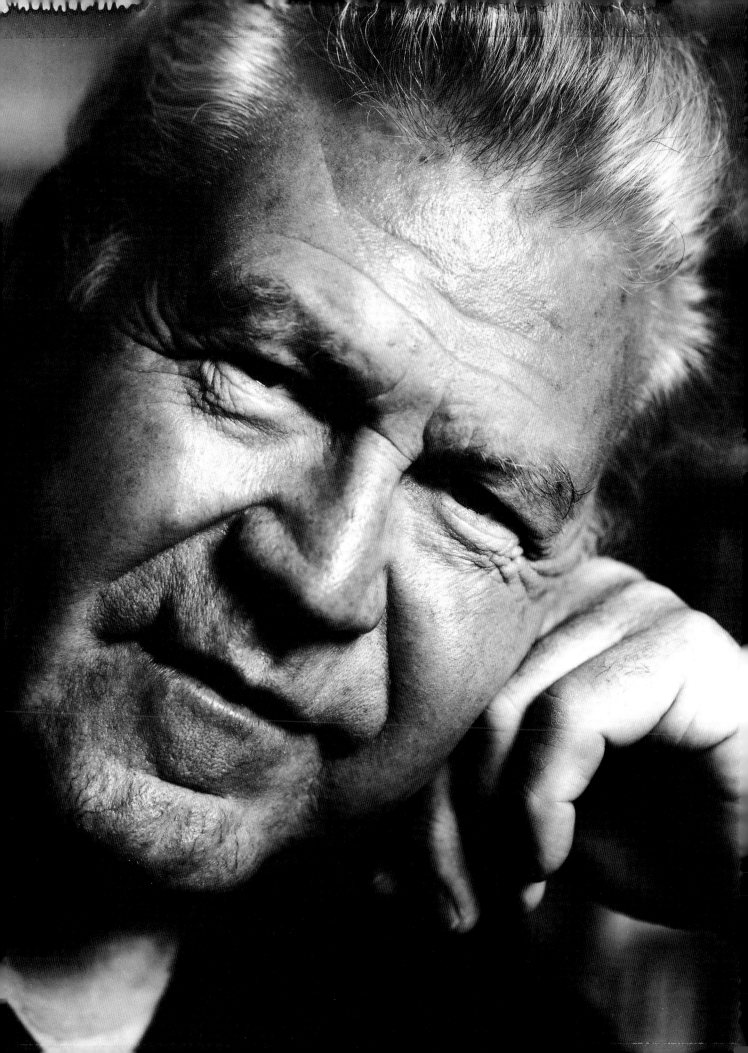

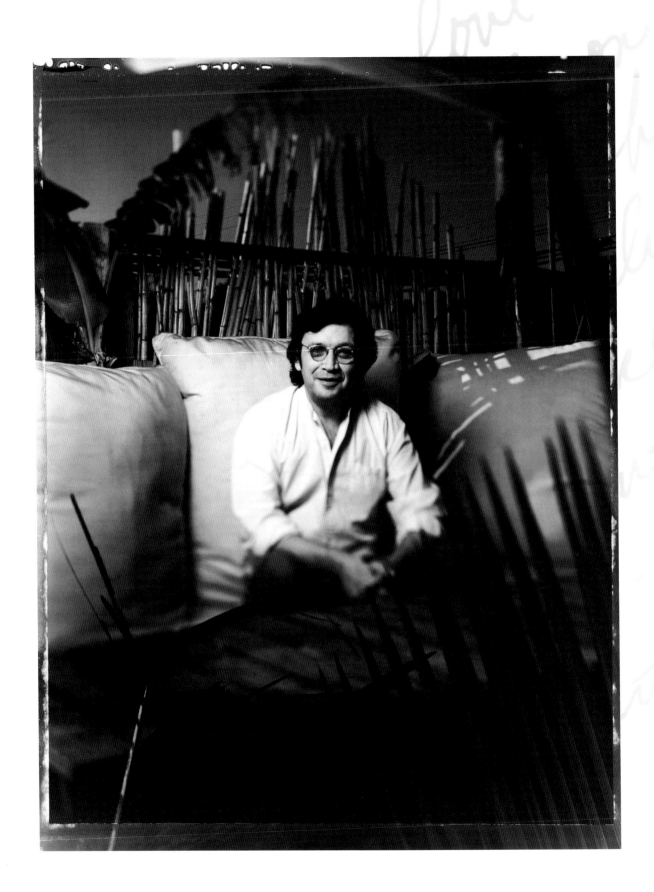

Shake Russell

"I fell in love with music early on in my life
. . . and have been traveling the highways
since I was old enough to drive! and . . .
there's more to come further up the road!"

February 8, 2006

Richard Dobson

"If you love it enough you can find a way to make it work."

April 2, 2005

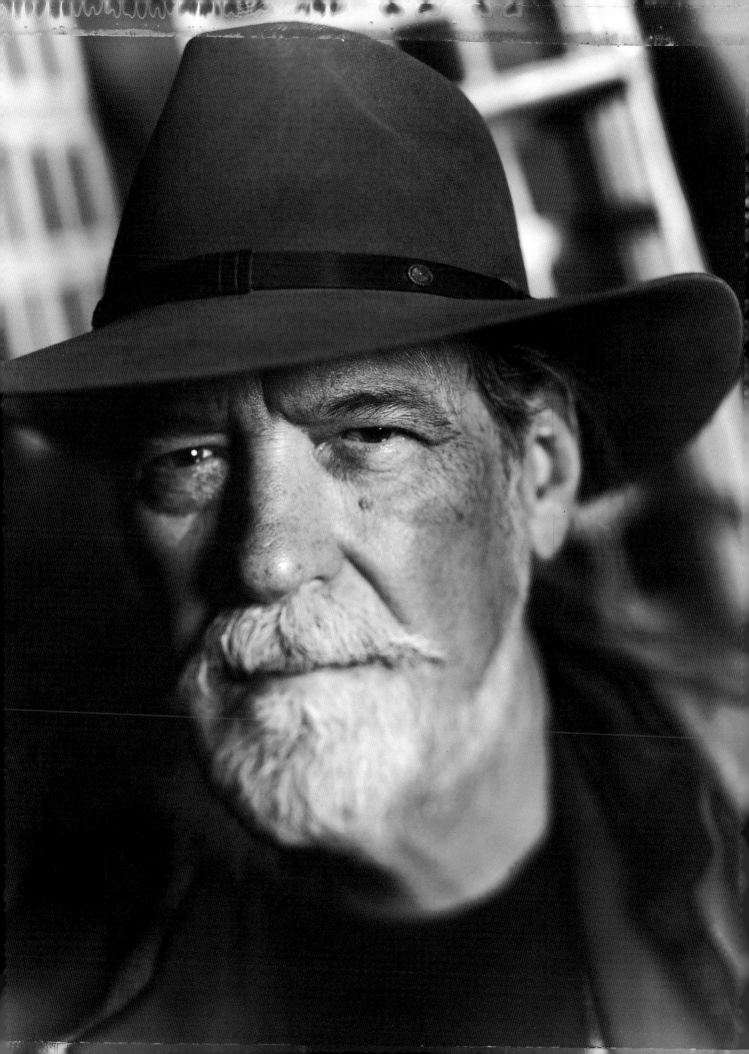

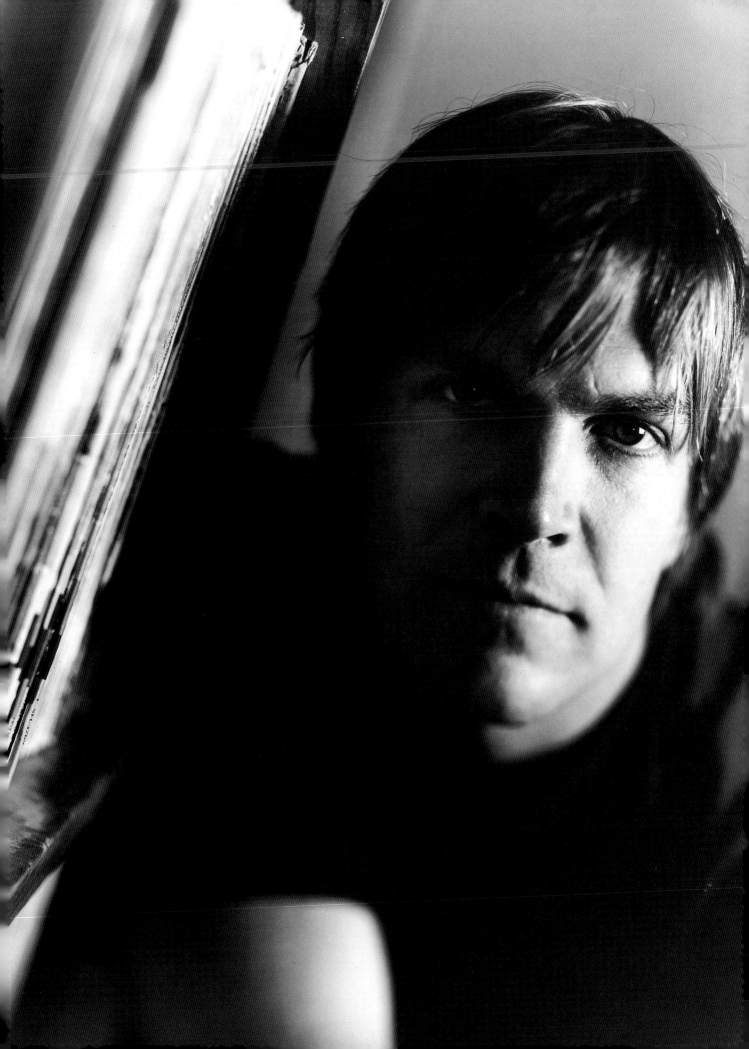

Jack Ingram

"They say 'money makes the world go
'round.' I say it's music."

November 22, 2003

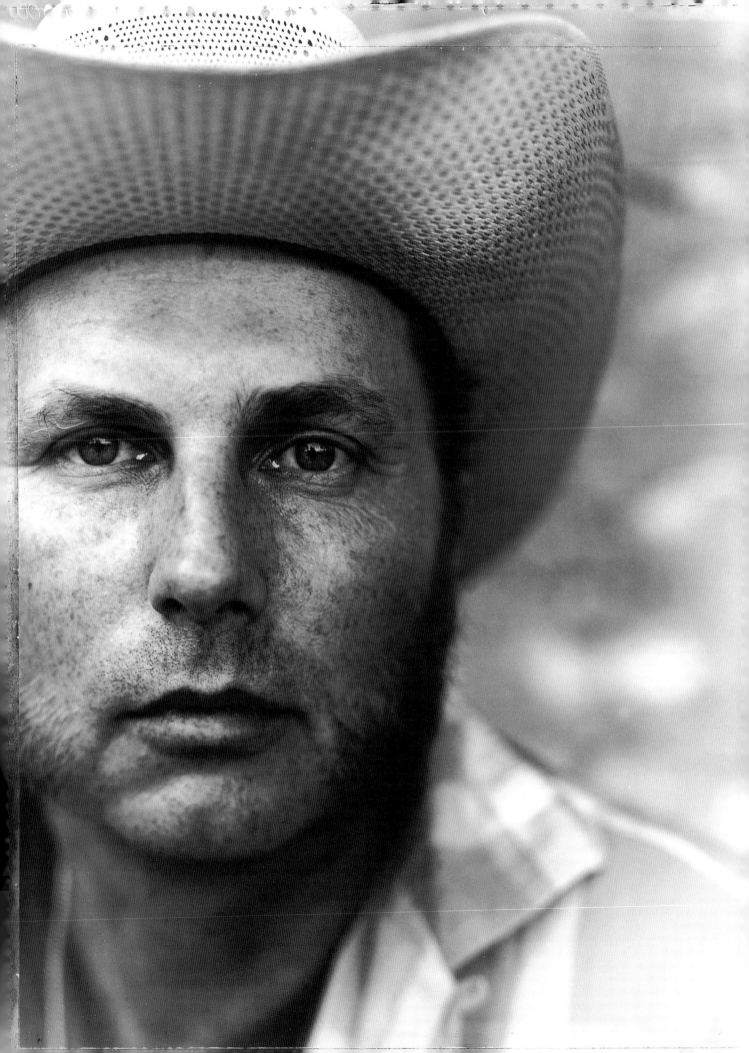

Mike Barfield

"Every song is really about one thing, it's corny but true. Love; the pursuit of it, loss of it, pain of it and all the bullshit that goes with it. I wonder if it means a thing when we're all 6' under. Oh well fuck it."

August 16, 2000

Jimmy LaFave

"It's not only the music it's the moments
& mystery that each new landscape brings
inside."

November 7, 2000

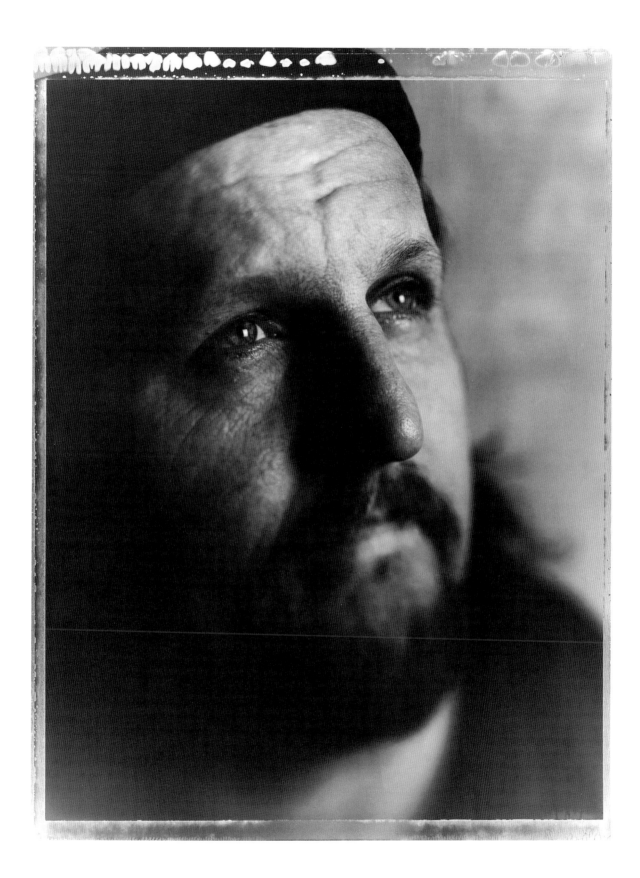

Trish Murphy

"What I love about songwriting is being finished. What I hate about songwriting is that it scares me. I do this because it's hard."

February 3, 2006

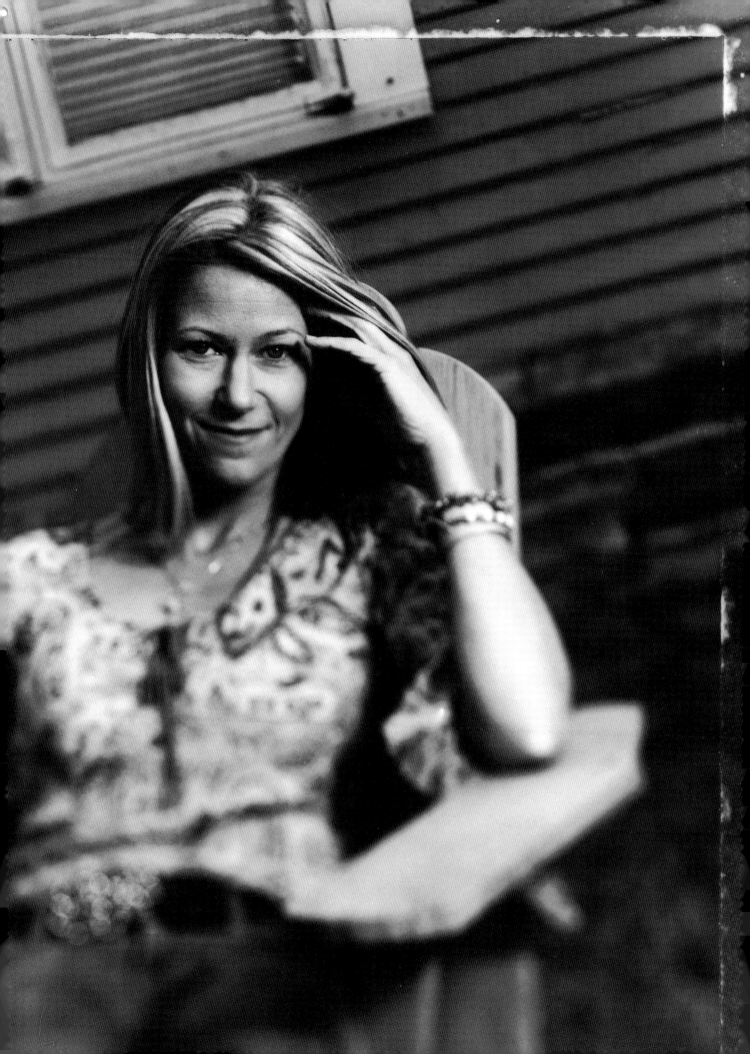

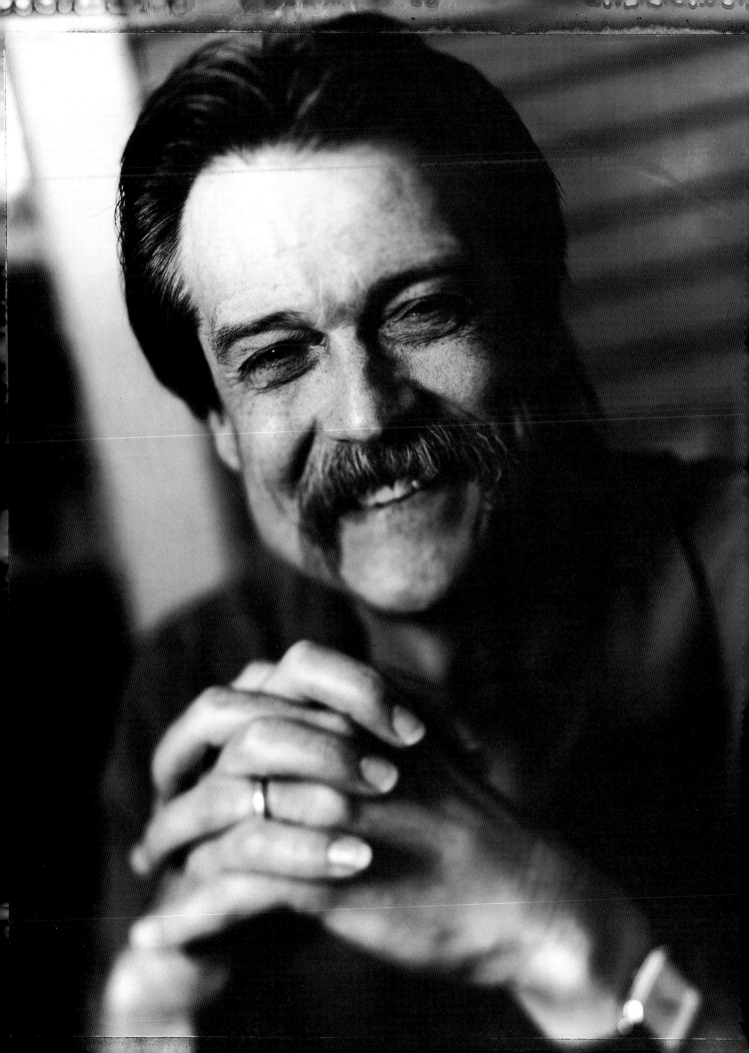

George Ensle

"**Of** all our god-given gifts hearing is the greatest, because it's music that moves our hearts to feel as one."

April 14, 2005

I would love to say
something — — — — —
about Well,
Texas, . . . that's a big
place . . . I've known
some people that thru
in together AND
we wrote songs from one
to the other . . .
takin pictures.

Eric Taylor

"I would love to say something — about . . .
. . . Well . . . , Texas, . . . that's a big place
. . . I've known some people that thru in
together . . . And we wrote songs from one
side to the other . . . I wish I'd been takin'
pictures."

March 28, 2002

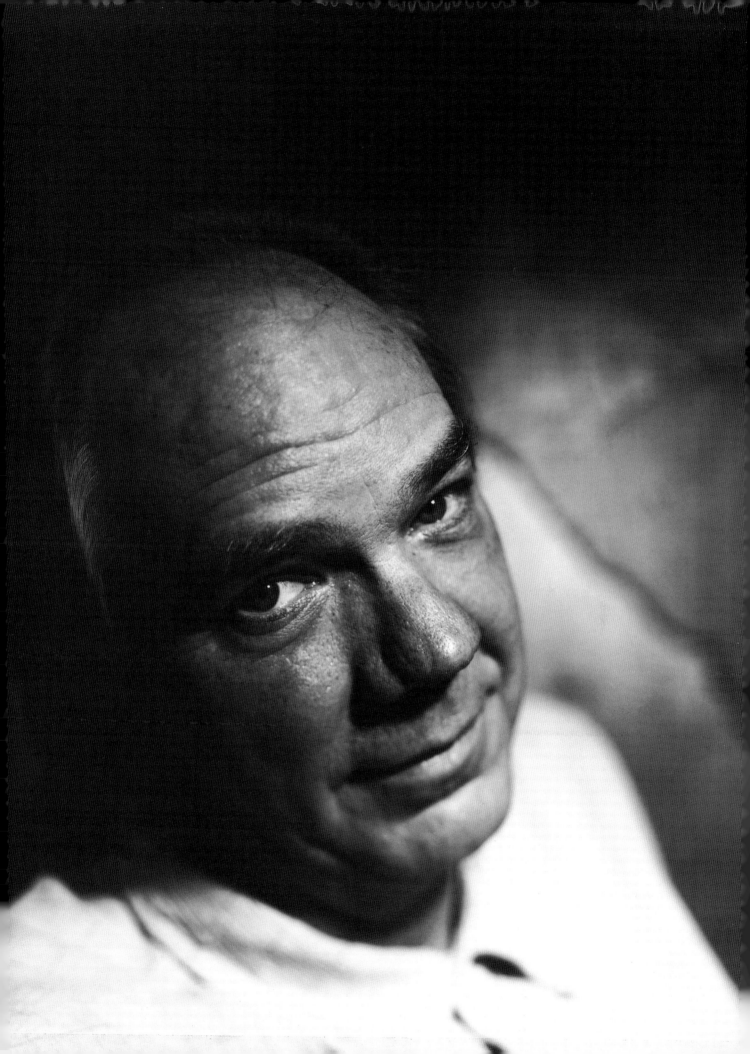

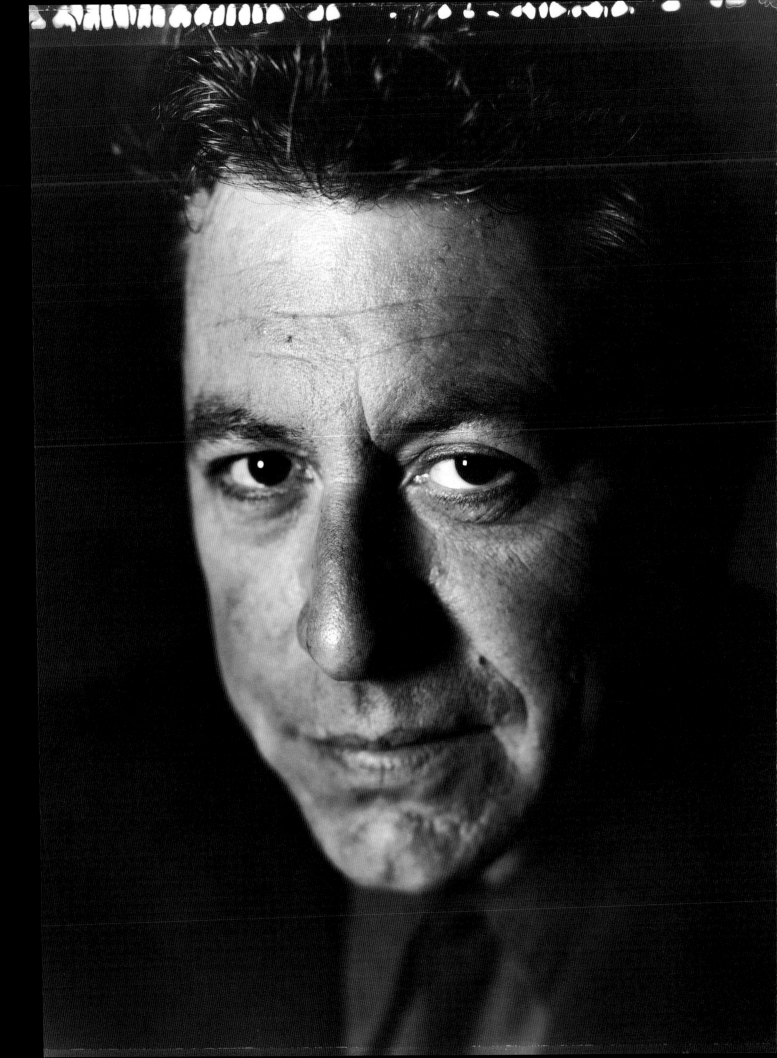

Joe Ely

"Up on the ridge, there's a fire about
to burn."

November 5, 2001

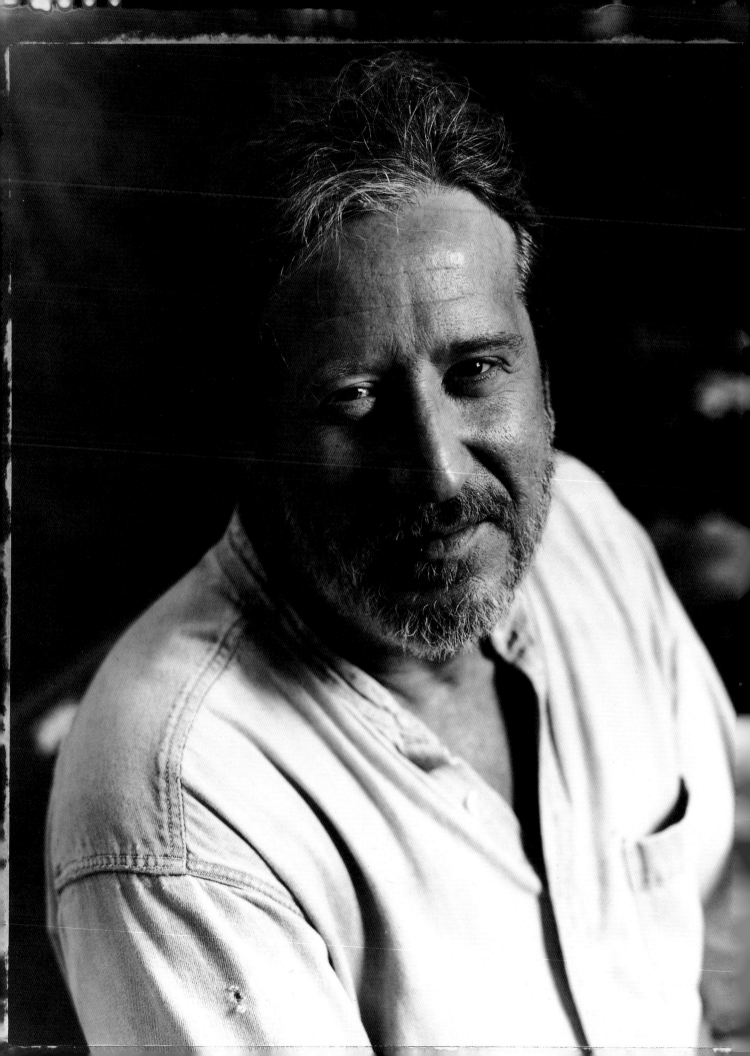

Vince Bell

"Ya see, the trick to this writing thing has always been to use the conventions to create an interpretation like no other. That day you and your songwriting buddies don't sound very much alike. Instead, you'll have . . . a lot in common."

May 19, 2001

Music will get ya
through the times
when there aint no money-
But money wont get ya
through the times when
there aint no music -

Jesse Dayton

"Music will get ya through the times when
there aint no money — But money won't
get ya through the times when there aint
no music."

June 26, 2000

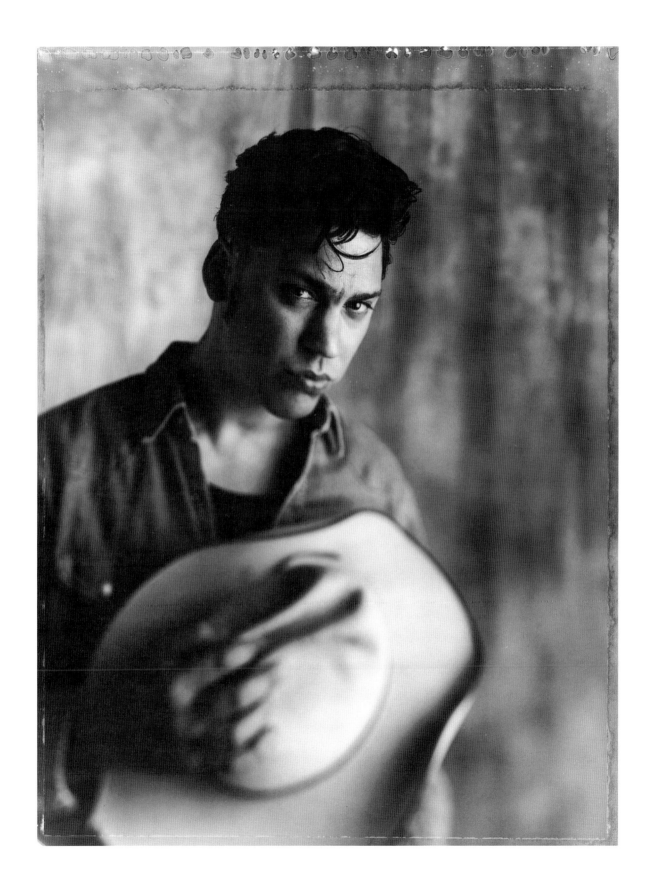

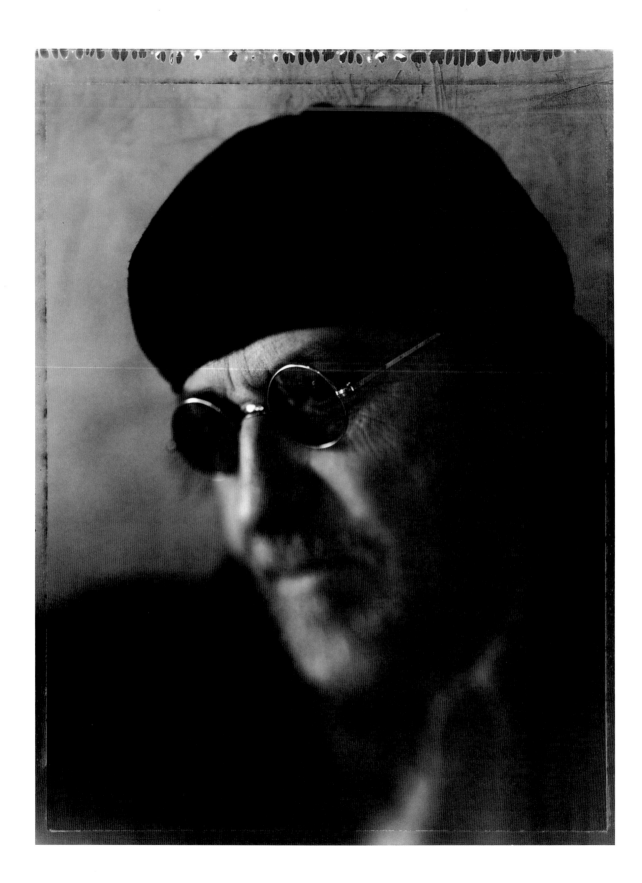

Ray Wylie Hubbard

"That part of us which responds to music
and truth is the best part."

February 3, 2001

THAT PART OF US WHICH
RESPONDS TO MUSIC AND
TRUTH IS THE BEST PART.

Ray is HUBBARD

WIMBERLEY, TX 2-3-2001

Lloyd Maines

"I feel very fortunate to get to work with
so many great artists. I wouldn't change a
thing about the musical path I've chosen.
Sometimes I think the music chose me . . .
I'm a lucky man."

October 28, 2000

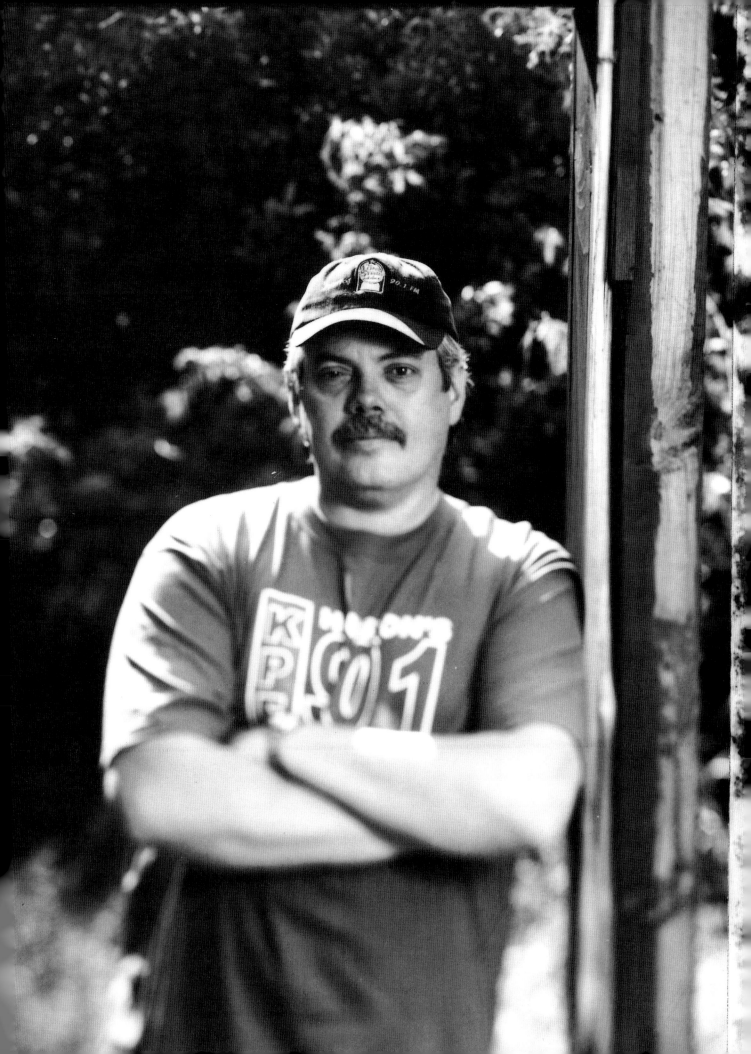

Willis Alan Ramsey
"So many piñatas, so little time."

July 28, 2001

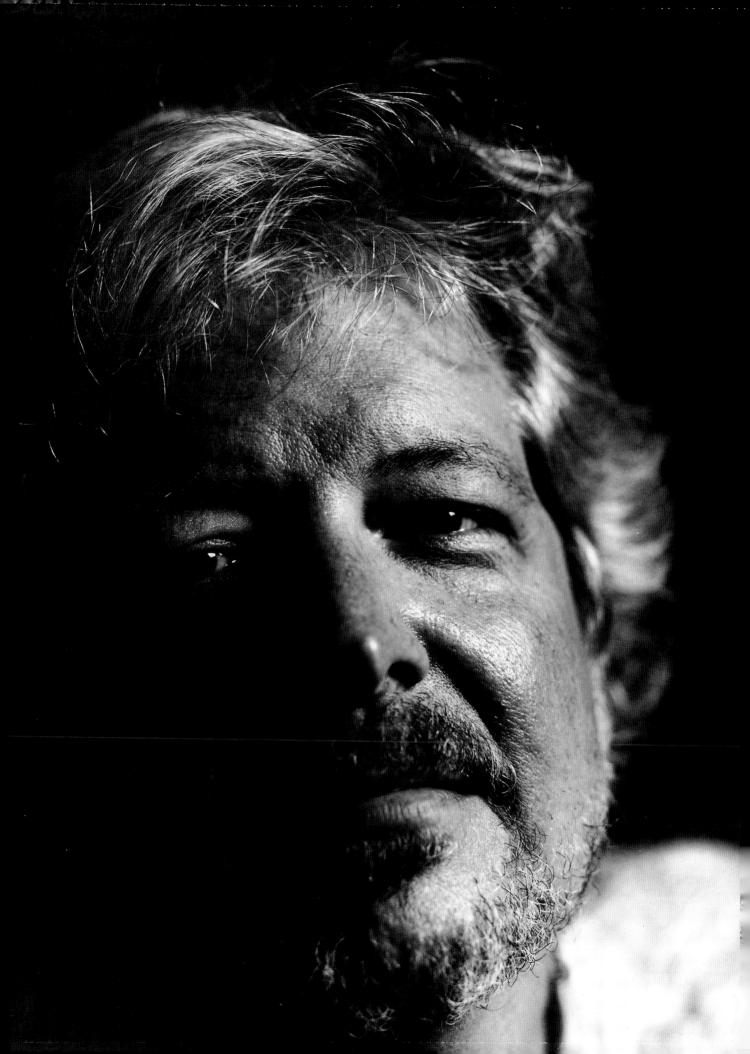

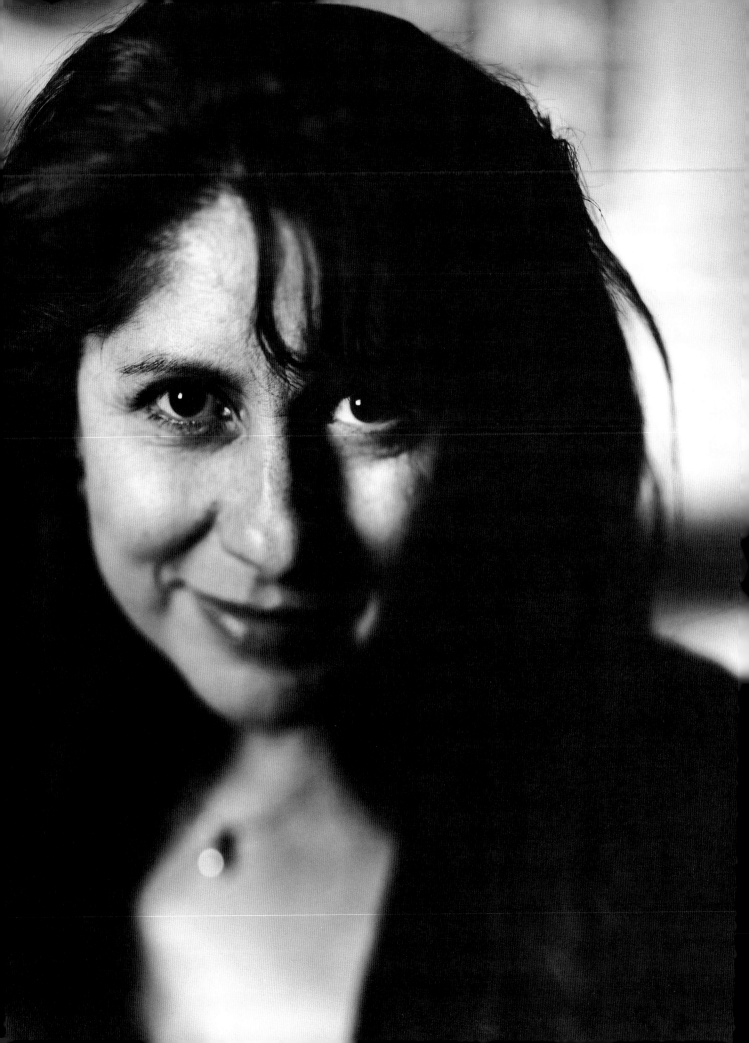

"Querer es Poder"
Love is power —
Tish Hinojosa

valentines
Day 2004

Tish Hinojosa

"'Querer es poder' Love is power—"

February 14, 2004

38

Michael Fracasso

"I used to think that life was a circle, but now I see a spiral; each generation further extending itself to God knows where."

August 17, 2000

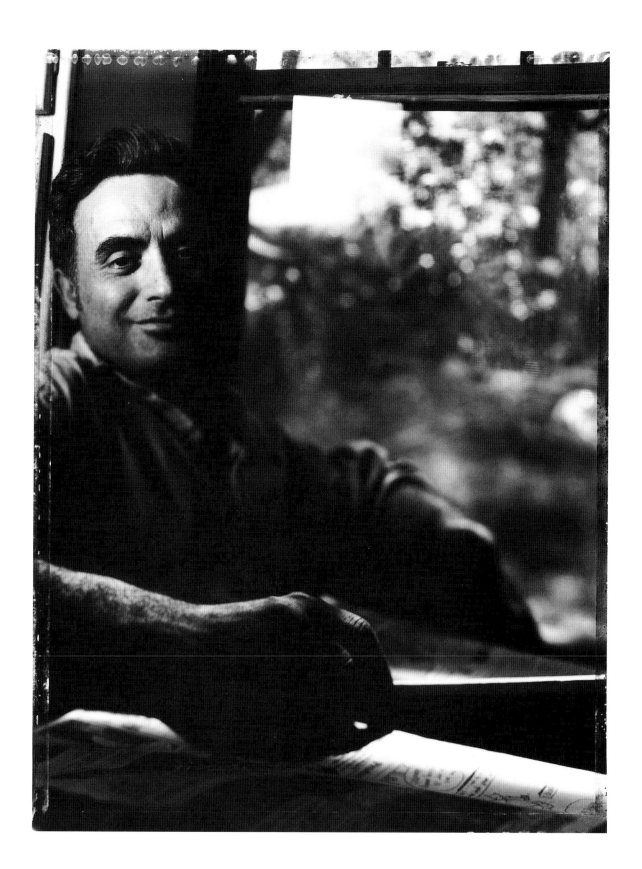

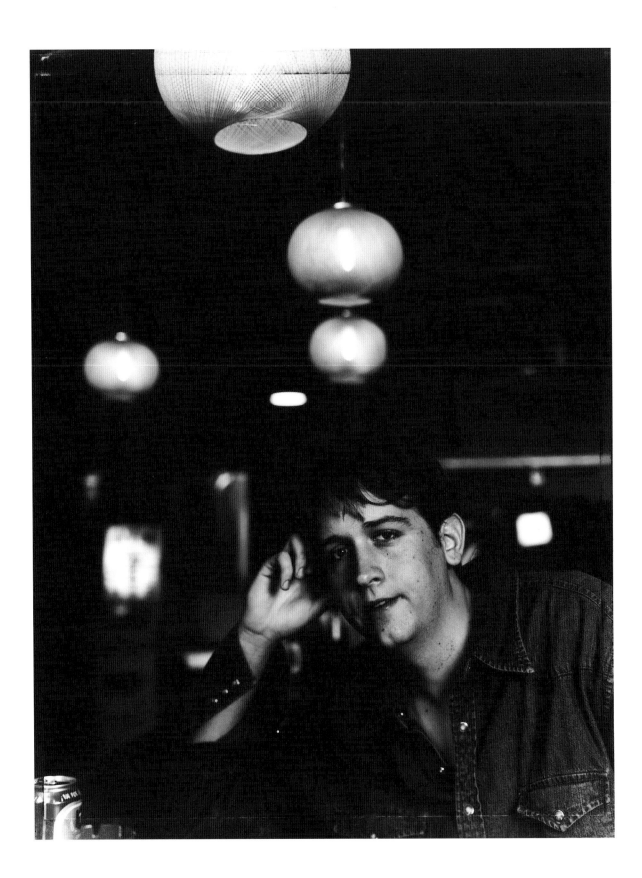

*I dreamed it
and the dream
came true.
That's all I can
ask for this time around*

*Hayes Carll
2/7/06*

Hayes Carll

"I dreamed it and the dream came true.
That's all I can ask for this time around."

February 7, 2006

42

Sara Hickman

"yes.
there's a true spiritual thrill of watching
strangers morph into one big happy pot of
love. when i see how simple it can be with
just a song, i wonder why it can't always
be this way? i thank god 25 hours a day.
joyfully & respectfully."

June 2, 2001

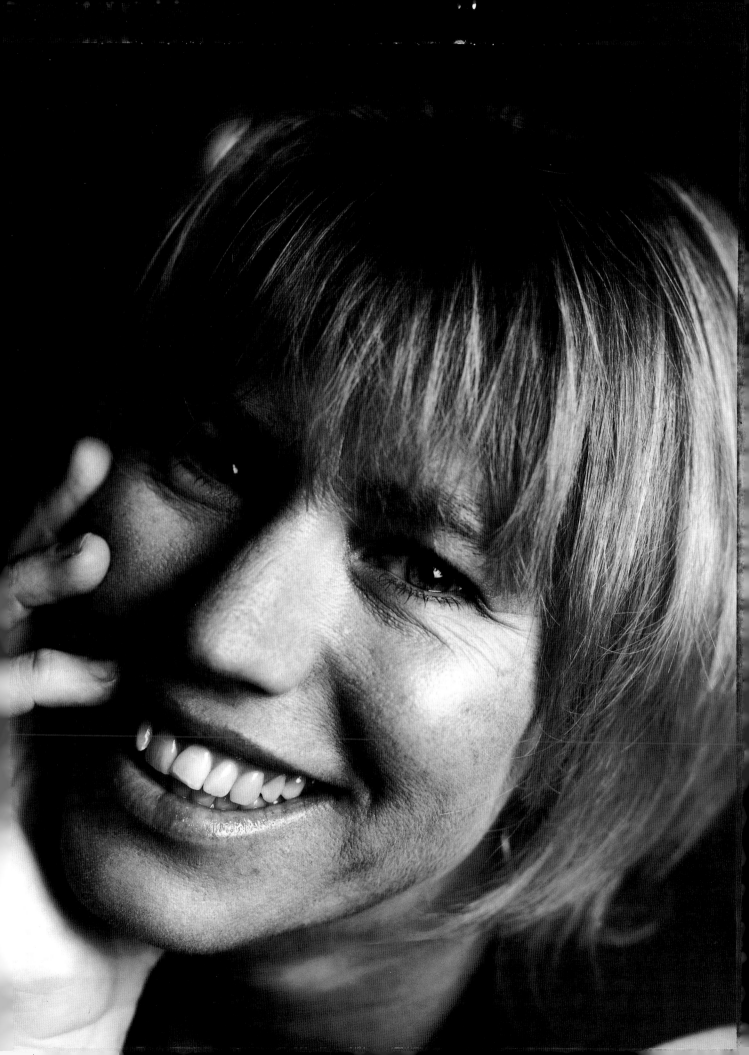

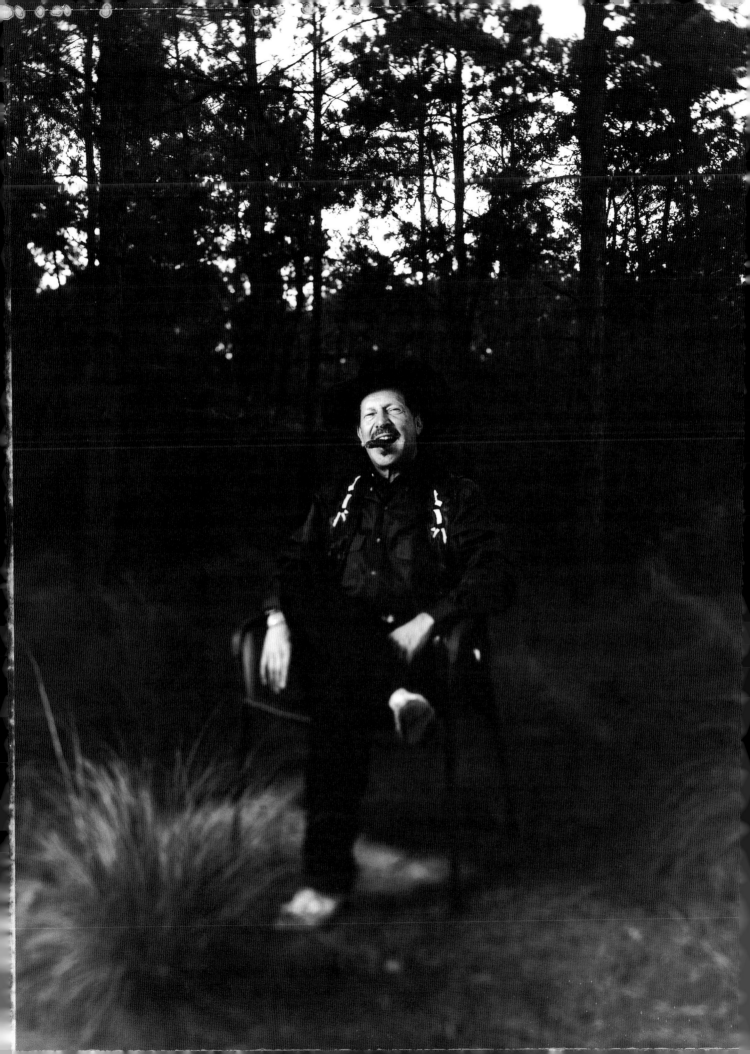

"I'd rather be a
dead Gram Parsons
than a live
Garth Brooks. "

Kinky Friedman

**"I'd rather be a dead Gram Parsons than a
live Garth Brooks."**

September 16, 2000

Rick Trevino

**"Music is not just lyrics and melodies
it's a way of life."**

April 9, 2005

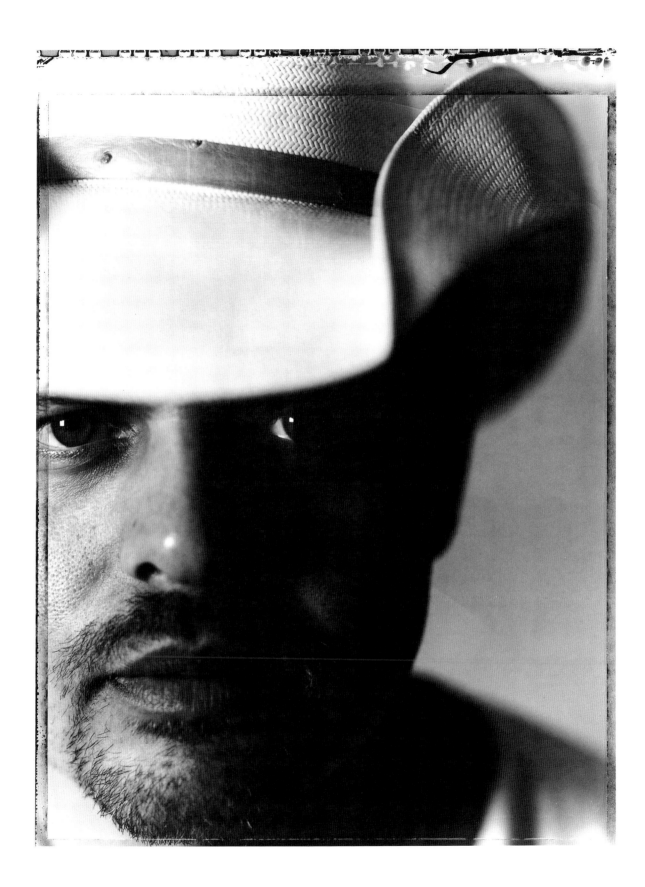

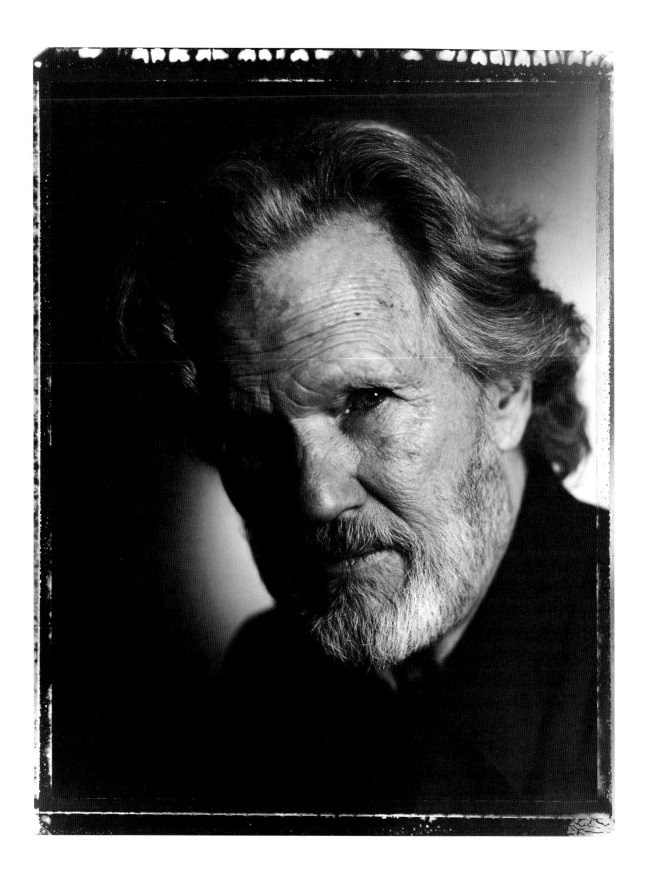

Kris Kristofferson

"You can leave Brownsville, but you'll never get the music of Matamoros out of your soul — Peace."

November 18, 2005

50

Lee Roy Parnell

"I guess the reason I don't live in Texas all the time is, I miss it more when I'm gone!"

September 10, 2005

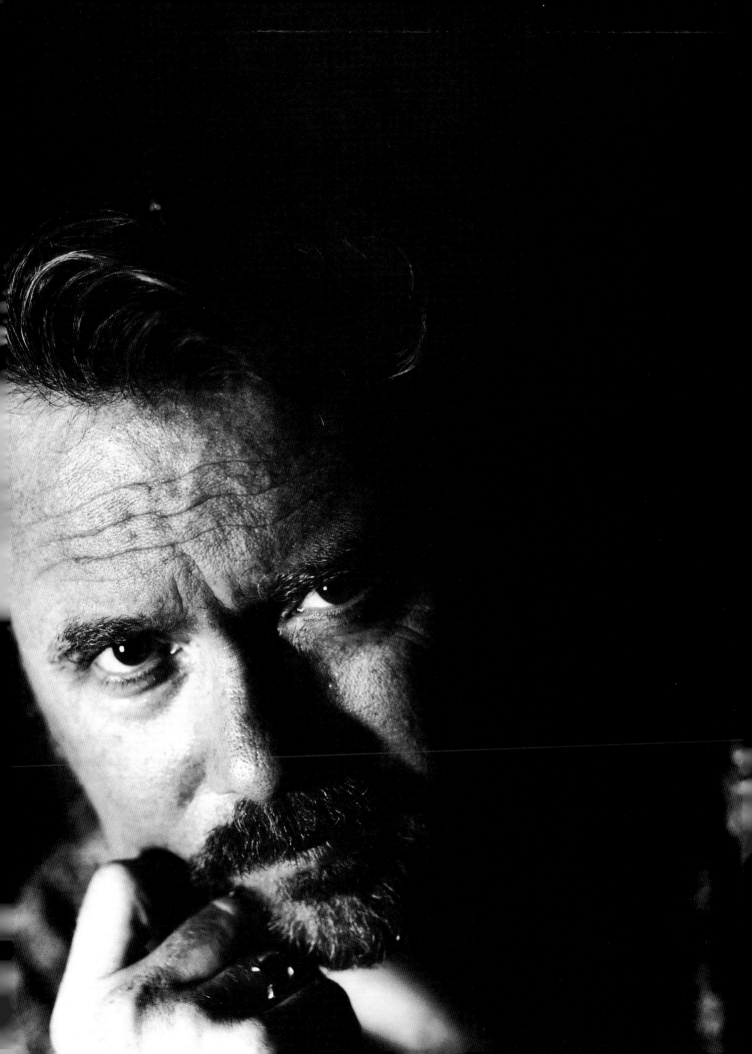

It's all about this Love
It's all about this Pain
It's all about the way

we break —

to Love again

Music is Medicine —

Amor

Alejandro Escovedo

"It's all about this Love
It's all about this Pain
It's all about the way
we break —
to Love again —.
Music is Medicine —.
Amor"

February 15, 2006

2/15/06

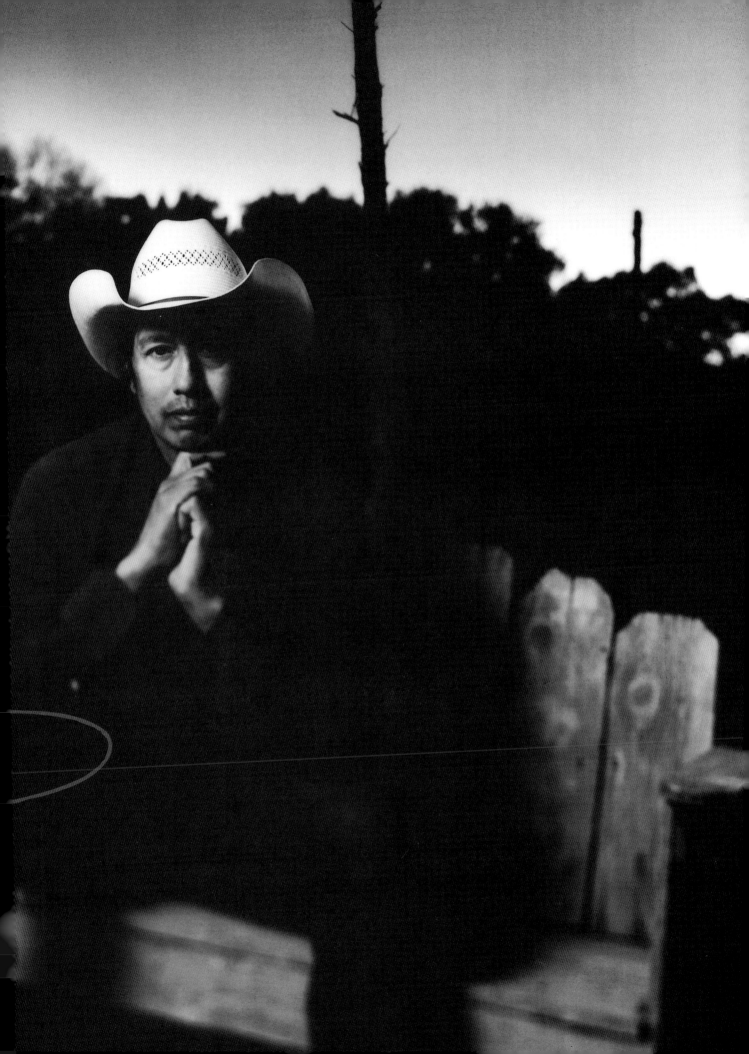

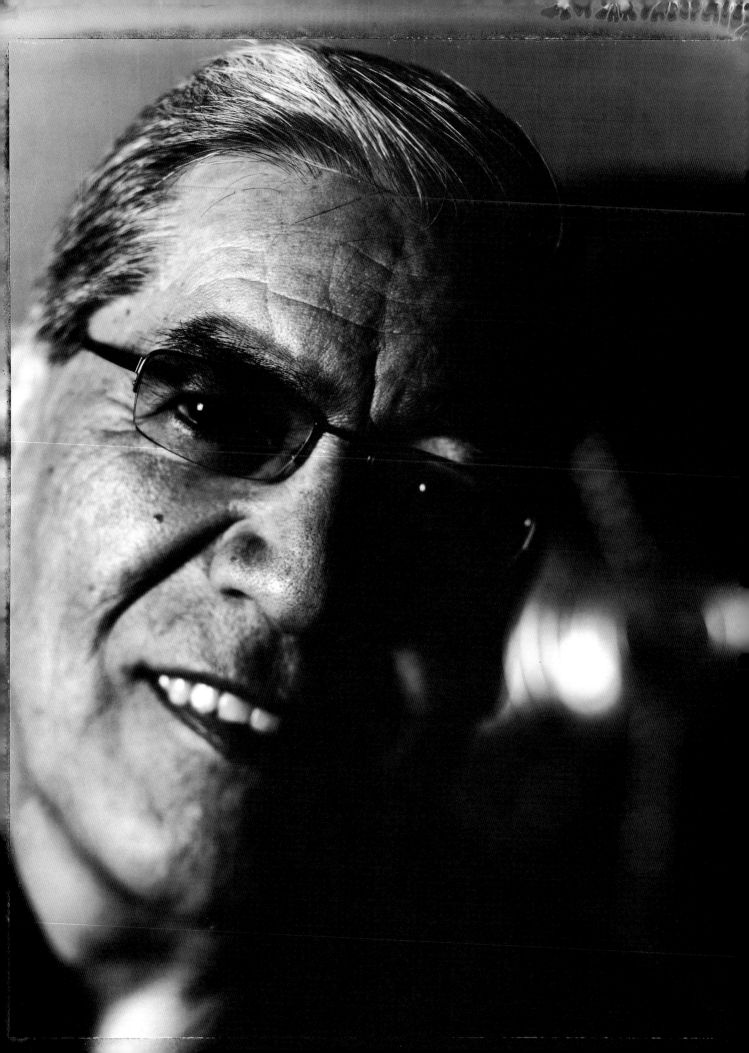

Ruben Ramos

"Yo doy millions y millions de gracias
a mi Dios-Jesús Christo por mi vida,
a mi padre Alfonso Ramos Sr., y a mi
jefa Elvira y a mis tíos — Juan Manuel
y Justin Pereza, & the ex-G.I.'s, por
introducing me a la música. Because
music is the best glue that unites people
together in harmony!!!"

April 13, 2005

Jimmie Dale Gilmore

"The Texas heart is as vast as the Texas
sky, and from the plains and hills and
rivers and mountains Music is how we
get there."

February 3, 2006

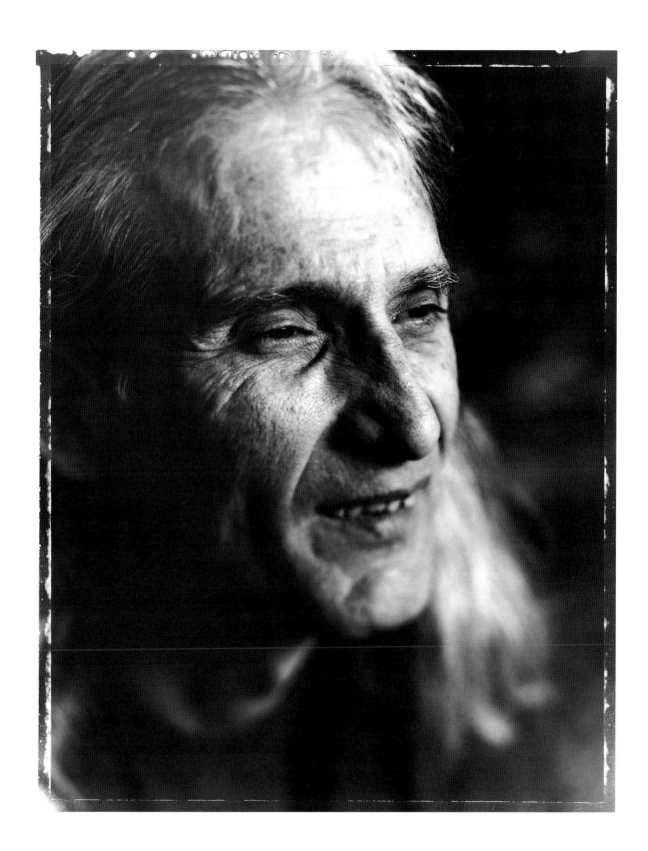

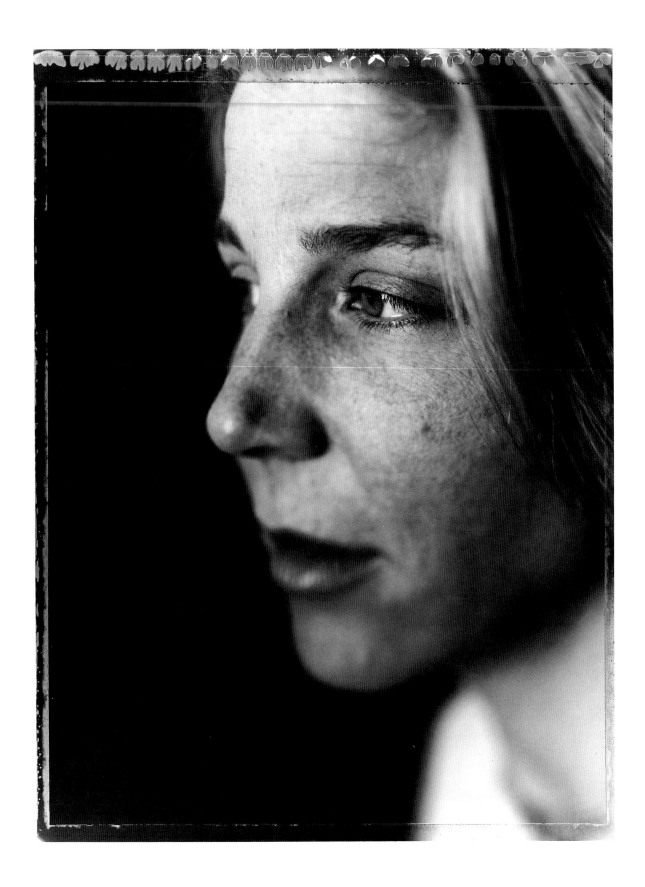

Terri Hendrix

"I enjoy playing music, buying music, listening to music, and watching people play music. I feel fortunate to get to do what I do for a living. Music is something I love."

October 28, 2000

60

Dale Watson

"Calloused hands or calloused hearts. Love
is what cures all."

August 20, 2005

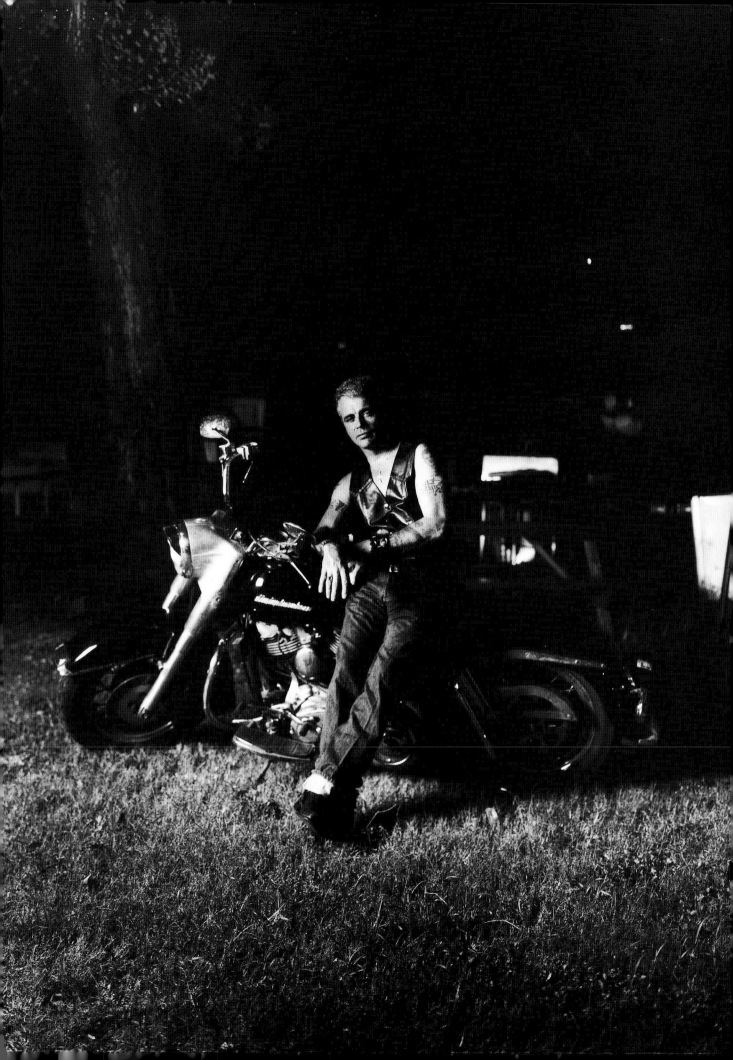

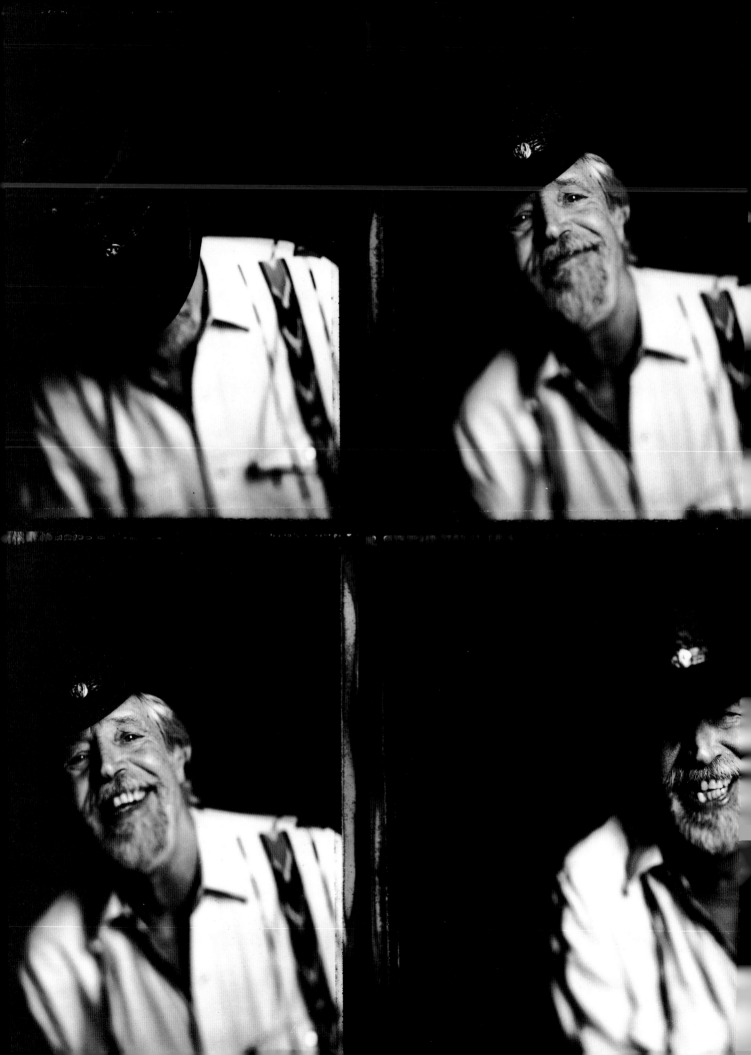

Rusty Wier

"It's better to shoot for a star and hit
a stump than to shoot for a stump
and miss it."

October 22, 2005

Sarah Fox

"Love like it's your last day on earth."

April 29, 2000

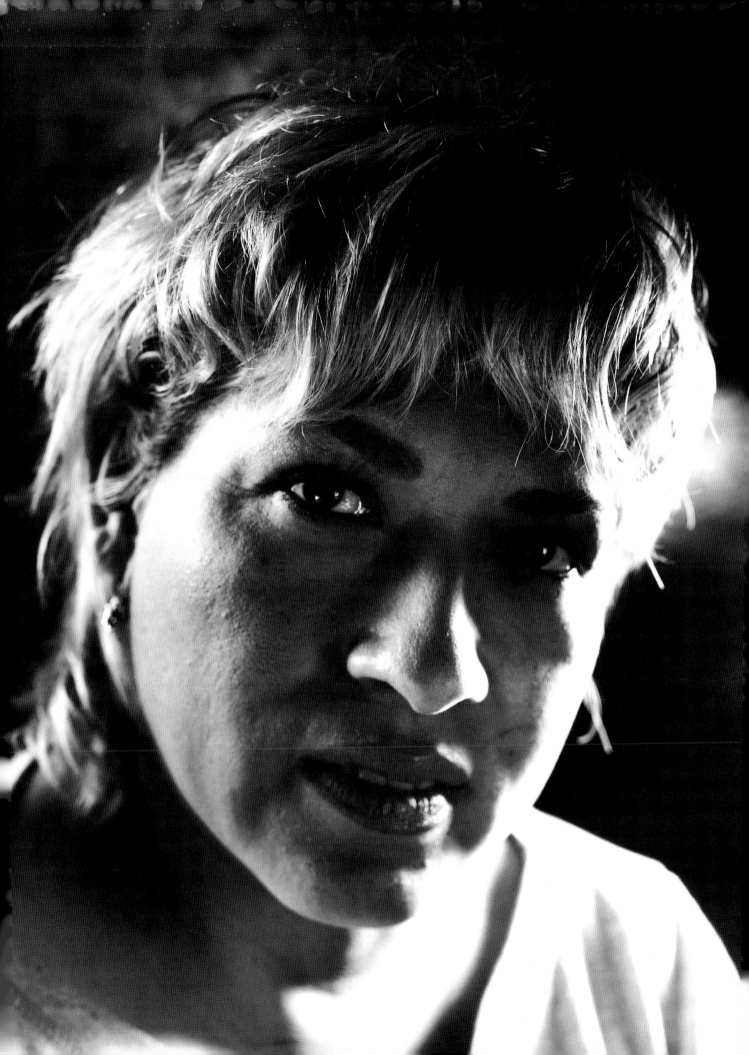

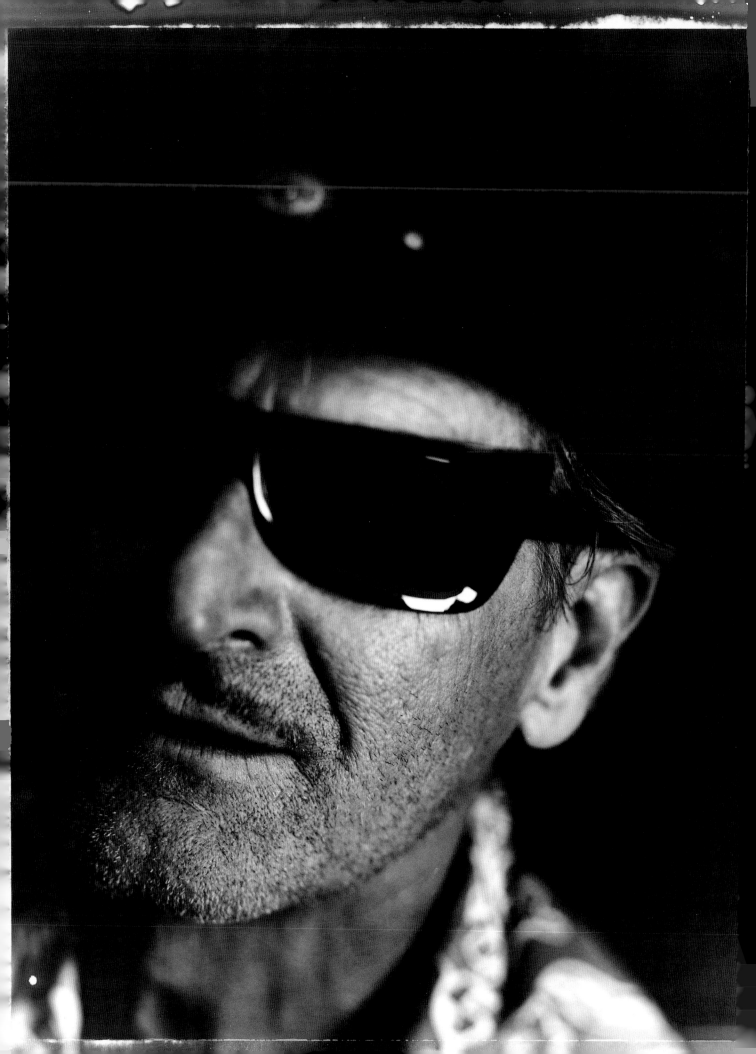

Butch Hancock

"They drummed 2 things into us in Lubbock
when we were growin up . . . 1) God loves
ya & he may just send you to hell . . . and
2) Sex is dirty, evil, nasty, bad, sinful and
you should save it for the one you love."

April 24, 2005

Abra Moore

"May the muse be with you and help color
your way."

February 3, 2006

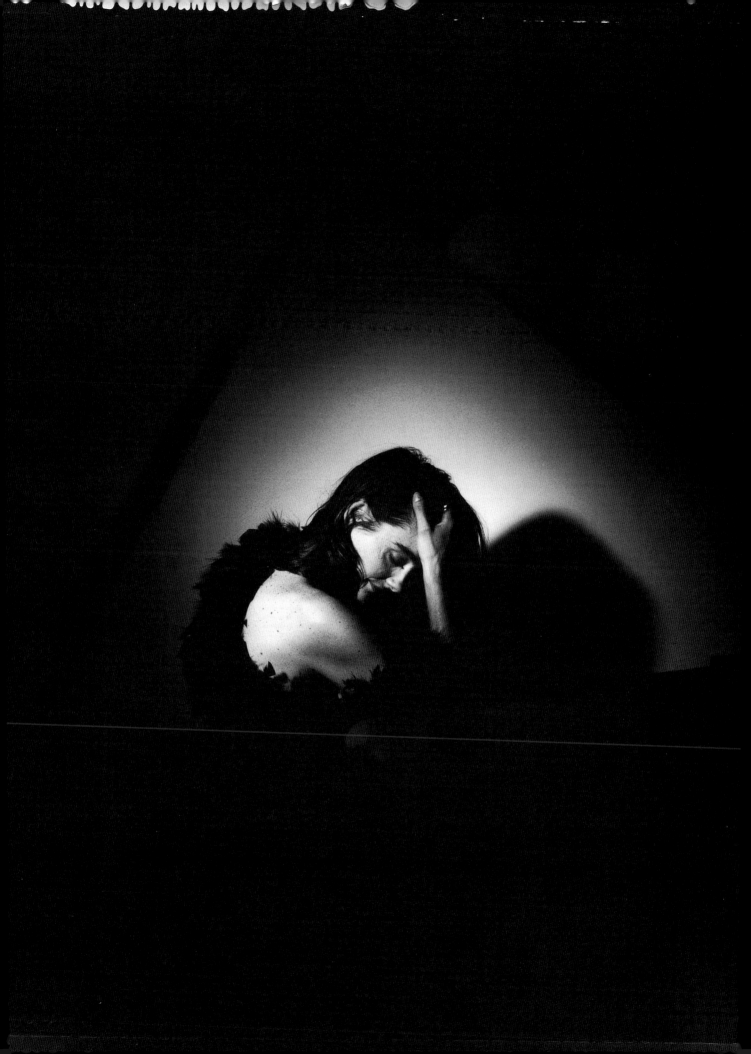

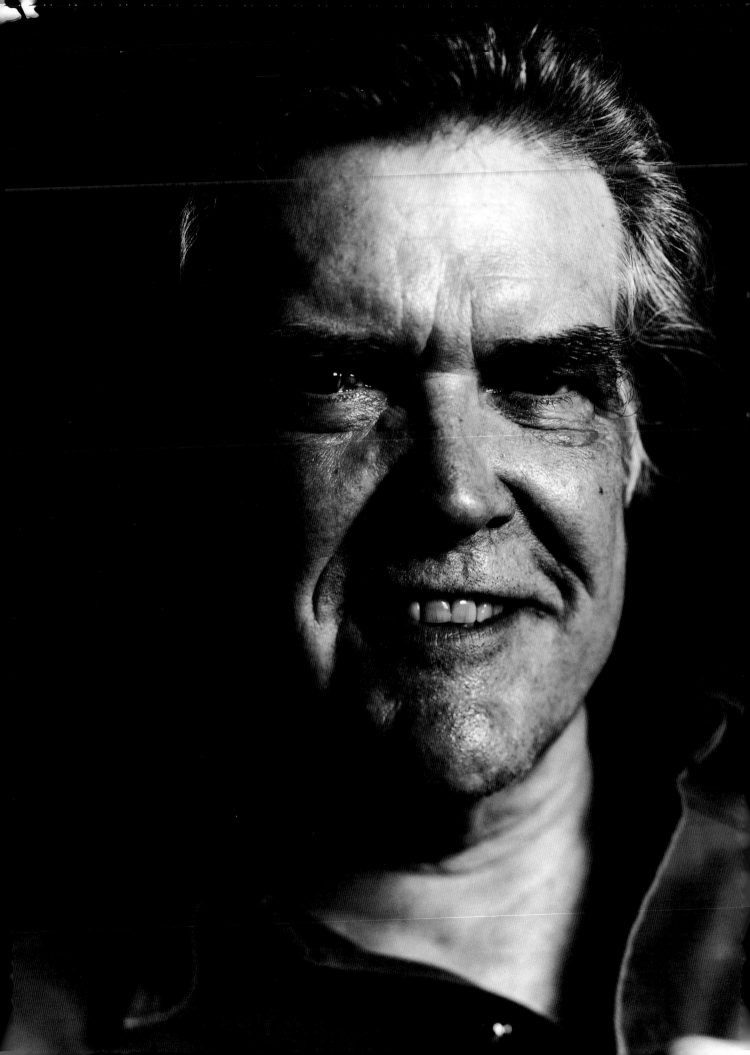

Guy Clark

"Songwriting is still a mystery to me —
maybe that's why I do it."

September 20, 2001

Davíd Garza

"Rock all night
Rock all days
Rock on"

September 8, 2001

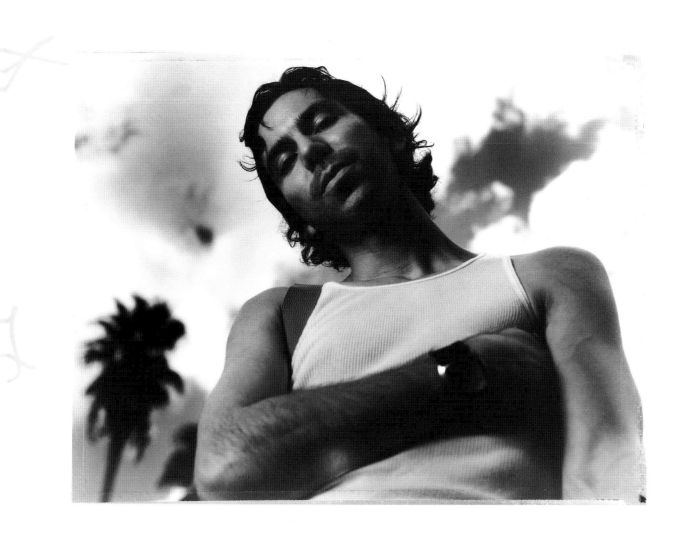

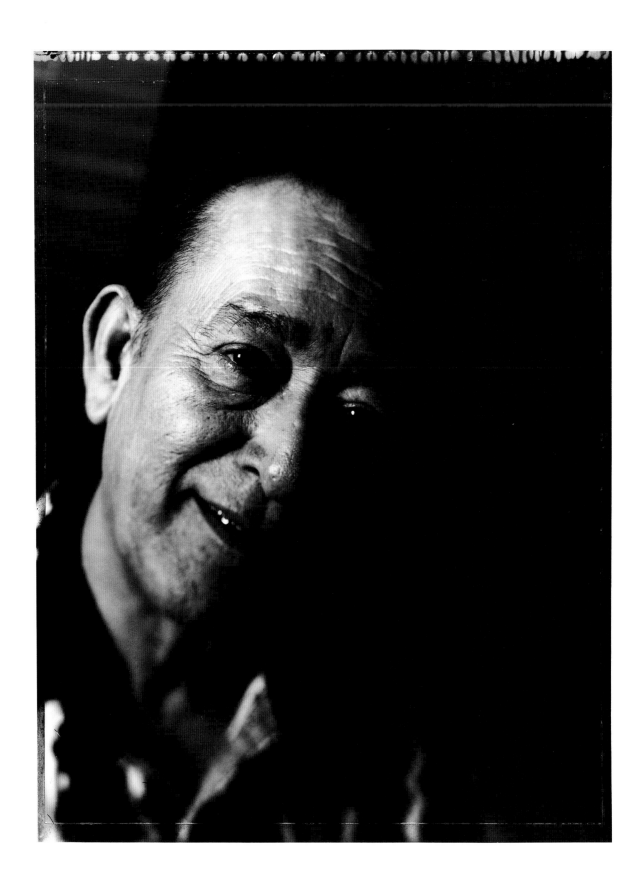

Flaco Jiménez

"Music to me is a beautiful round world.
And sharing different cultures in music,
makes it even rounder."

August 17, 2000

MUSIC IS THE SHORTEST DIS-
TANCE BETWEEN TWO QUESTION
MARKS —? LA DE DAMN
DA?

Terry Allen

"Music is the shortest distance between two
question marks — ? La de damn da?"

April 30, 2005

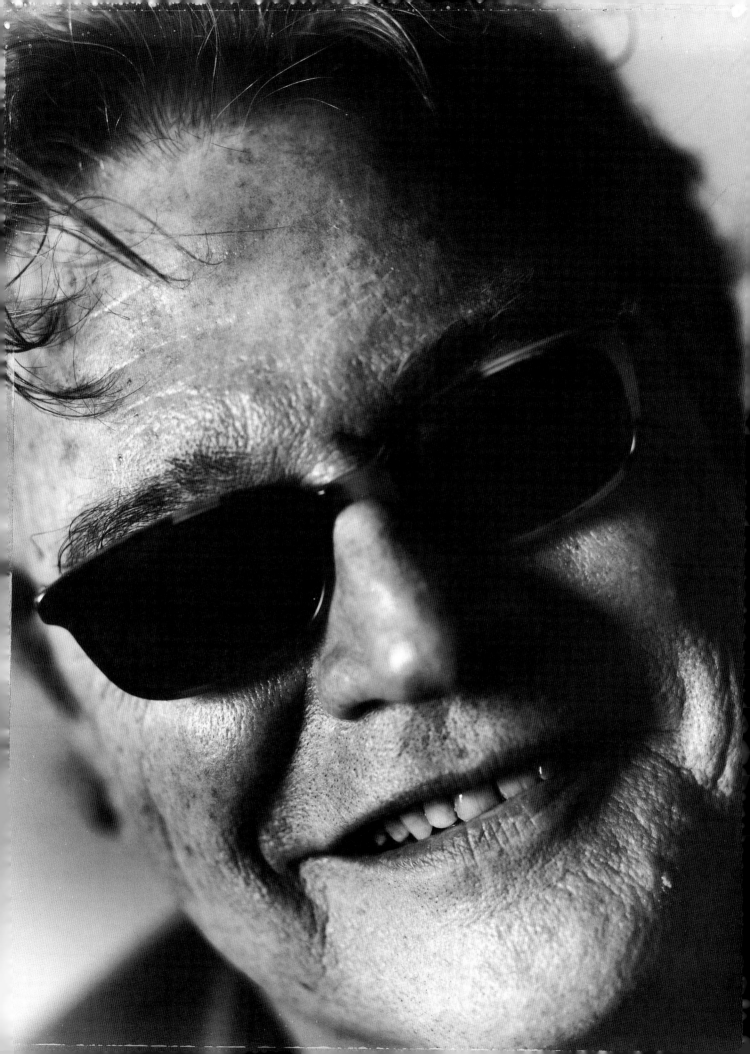

Patrice Pike

"What I've noticed about music is that 2 people who are would-be enemies suddenly can know, understand and love each other in a moment in the presence of music together. Amazing Grace!"

February 4, 2006

When all else fails,

Music prevails!

— Bob Livingston

Bob Livingston
"When all else fails, music prevails!"

January 14, 2006

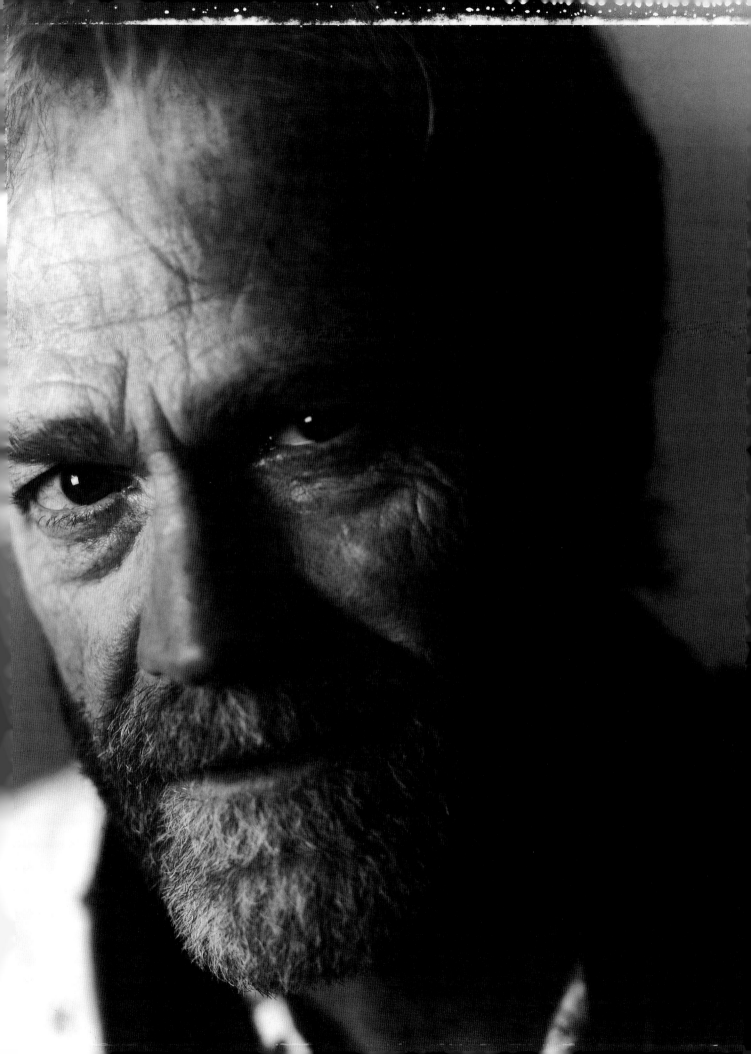

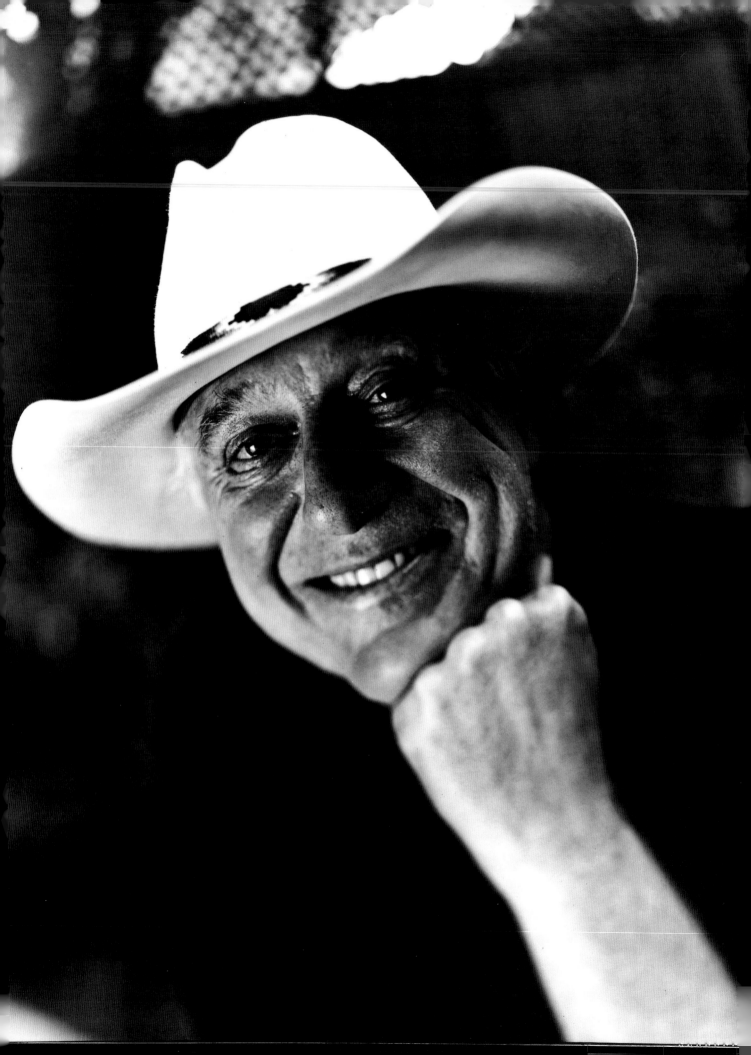

Jerry Jeff Walker

"Music & the open highway have given me
quite an adventure."

September 5, 2002

James McMurtry

"I got into the game a bit late. I had almost
forgotten how to fly. Young people can fly
because they don't know that they can't.
I'm almost young enough again."

April 13, 2006

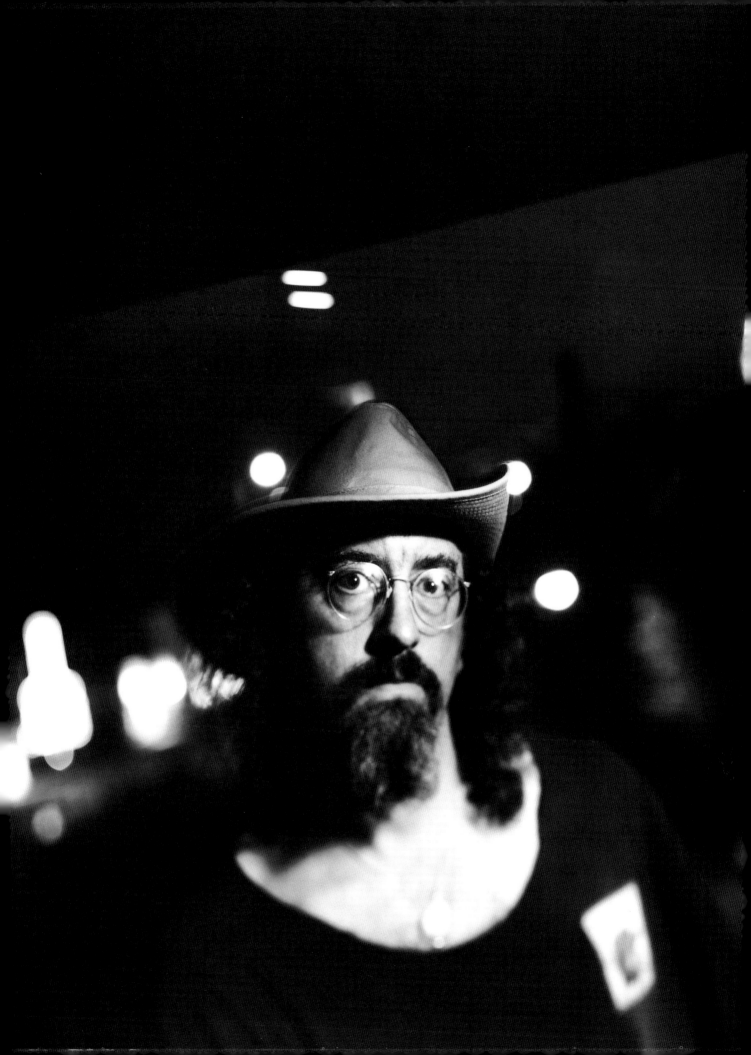

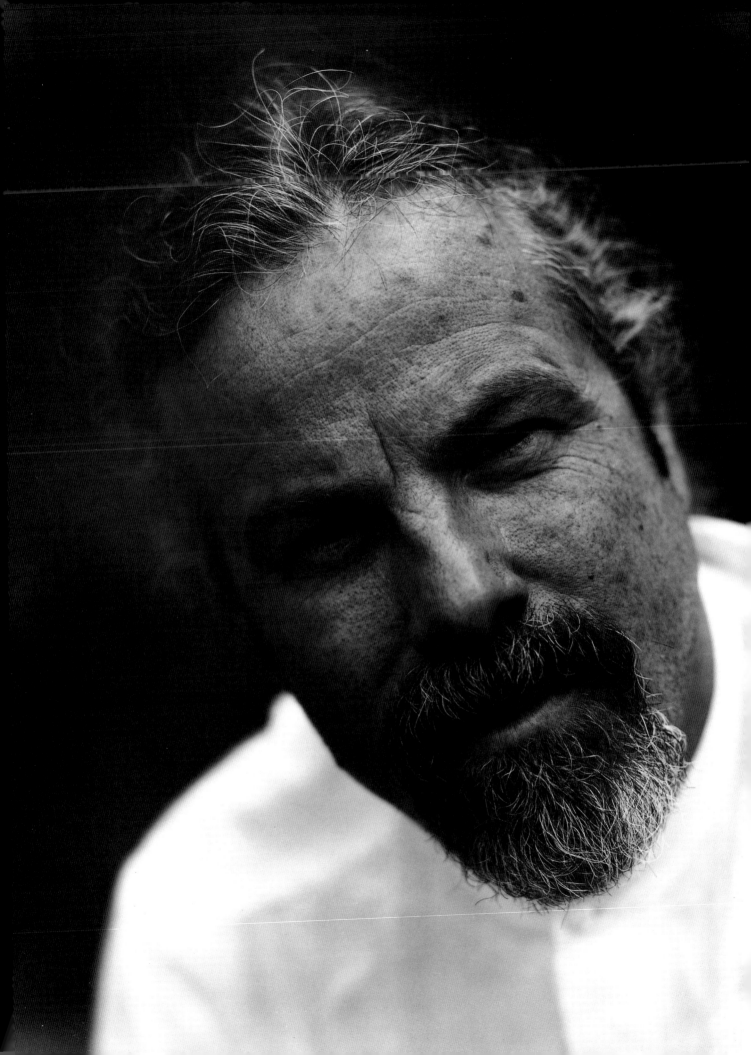

I MEASURE MY LIFE in MUSICAL EXPERIENCES. YOU KNOW, LATE NIGHTS WITH NANCI GRIFFITH & DELORES KEANE SINGING IRISH SONGS, SAM BUSH PLAYING MY OLD MANDOLIN, PICKING ON THE PORCH... ANY PORCH. BY MY MUSICAL YARDSTICK, I'M LIVING A HELL OF A LIFE.

Robert Earl Keen

"I measure my life in musical experiences. You know, late nights with Nanci Griffith & Dolores Keane singing Irish songs, Sam Rush playing my old mandolin, picking on the porch . . . any porch. By my musical yardstick, I'm living a hell of a life."

October 11, 2003

88

Sisters Morales (Lisa [quoted] & Roberta)

"I wanna dream big, keep hope, love large
& change the world! Every night when I'm
on stage I think 'God! I love what I do!'
Hope I can do this until I die."

August 13, 2005

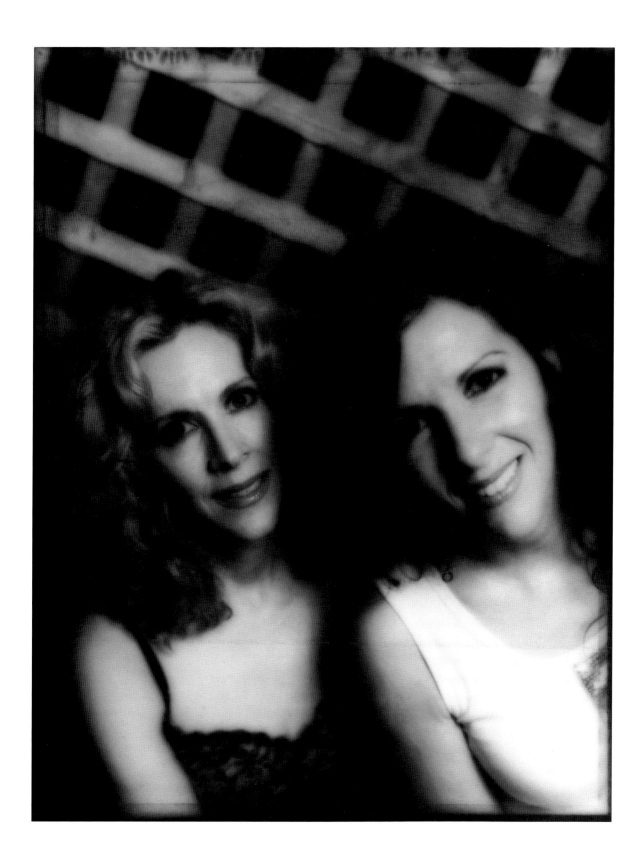

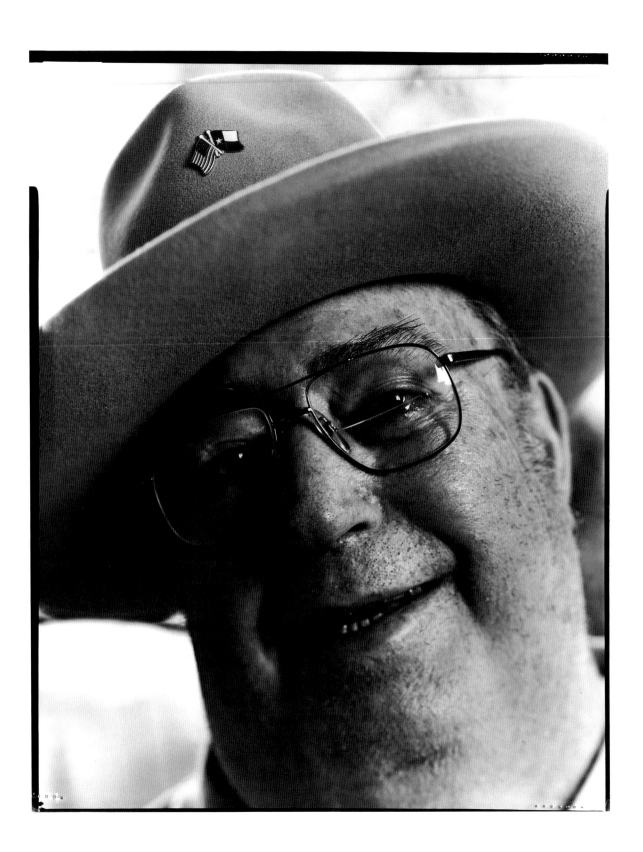

Don't get hooked on anything but your dreams.

Don Walser

Don Walser

"Don't get hooked on anything but your dreams."

September 5, 2002

Mingo Saldivar

"Music is my first love, next to 'God.' It's so awesome to work at something that you really love to do — and on top of that, get paid for it!"

June 19, 2002

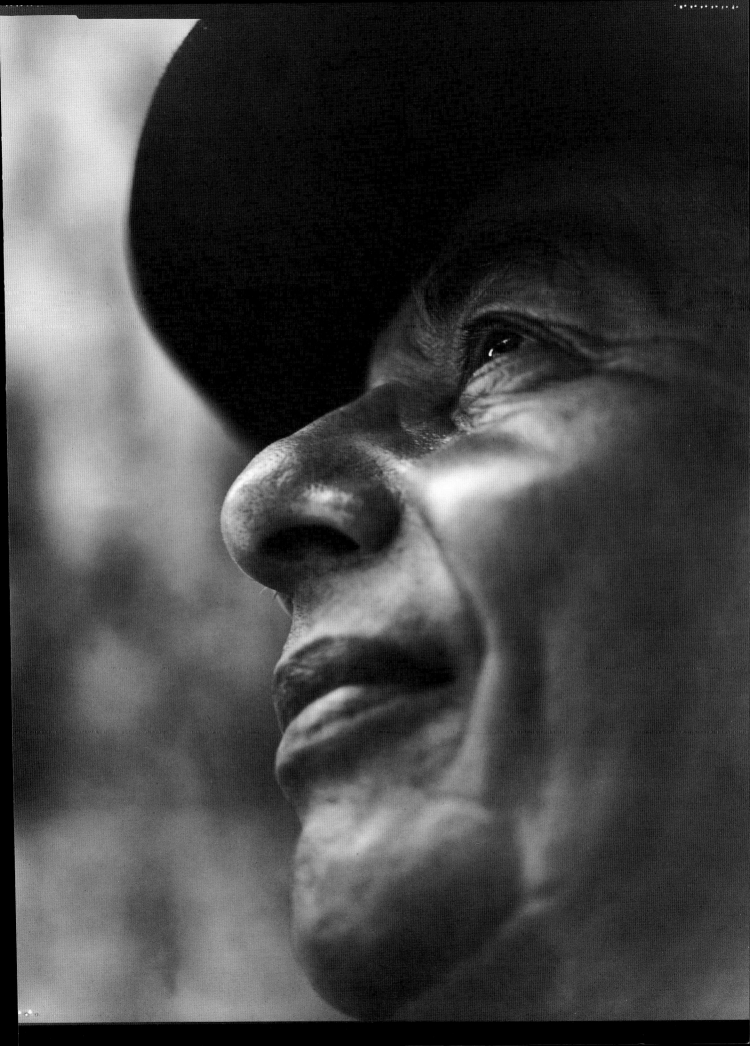

JOEL GUZMAN Producer/Accordionist

The history of our Texas is so incredible, from the Texas Indians to the Spanish conquistadores. There were so many tribes and so many different languages that the Indians had to develop sign language, using hands and fingers to picture what they wanted. In this same way we use our hands and fingers to communicate to the world about Texas culture, our bloodlines, our hardships thru our instruments, and our songs. Texas music is multi-dimensional: country music mixed with accordion, bilingual songs sung by American singers, Cuban/Mexican singers singing the blues . . . conjunto being played by Czech accordion players . . . the combinations are endless and it's crazy but so wonderful! This mixture of cultures and languages is the root of Texas music and its soul . . .

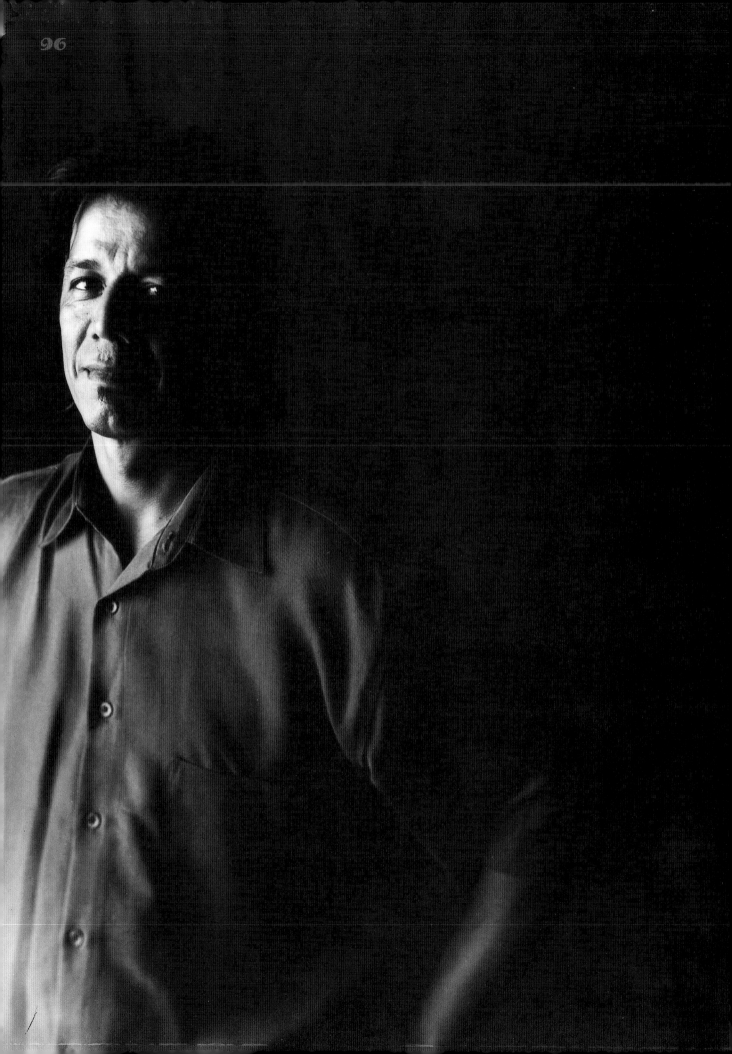

Joel Guzman

"My best production so far has been my son
Joel Gabriel. Music would have no meaning
without him and Sarah. Life is good. Truly."

August 3, 2000

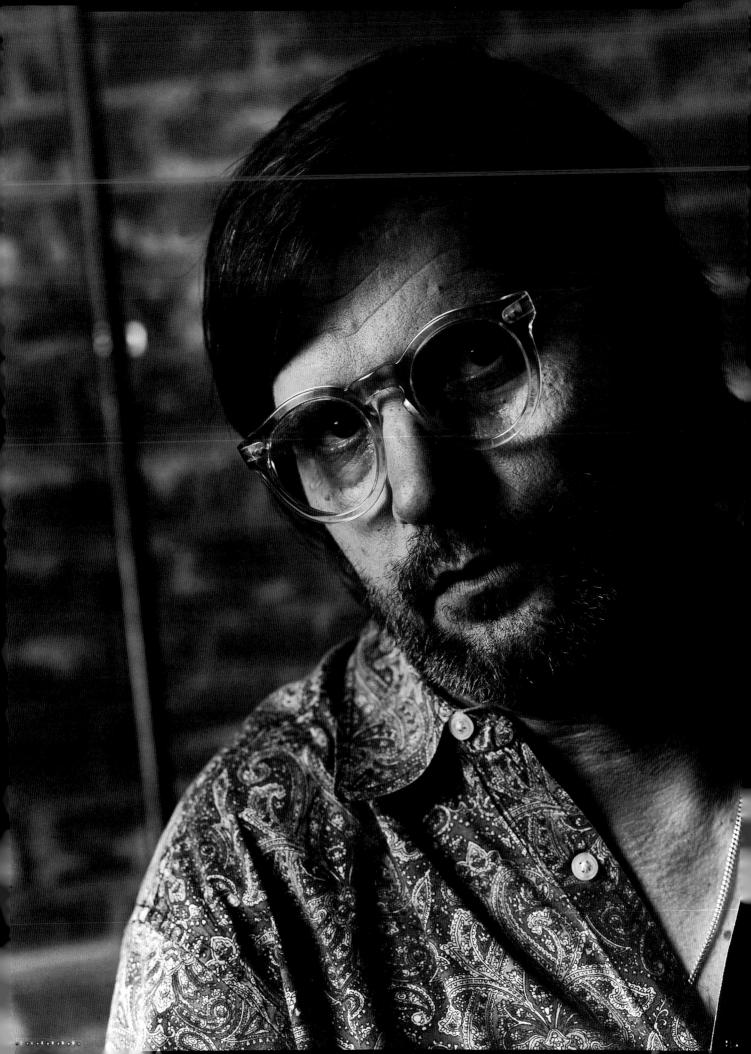

Steve Earle

May 3, 2003

Rosie Flores

"Highway signs, smoky bars, dancers wearing cool country threads, shots of tequila lined up at the bar, a good listening crowd and my band rockin — These are a few of my favorite musical things."

November 3, 2001

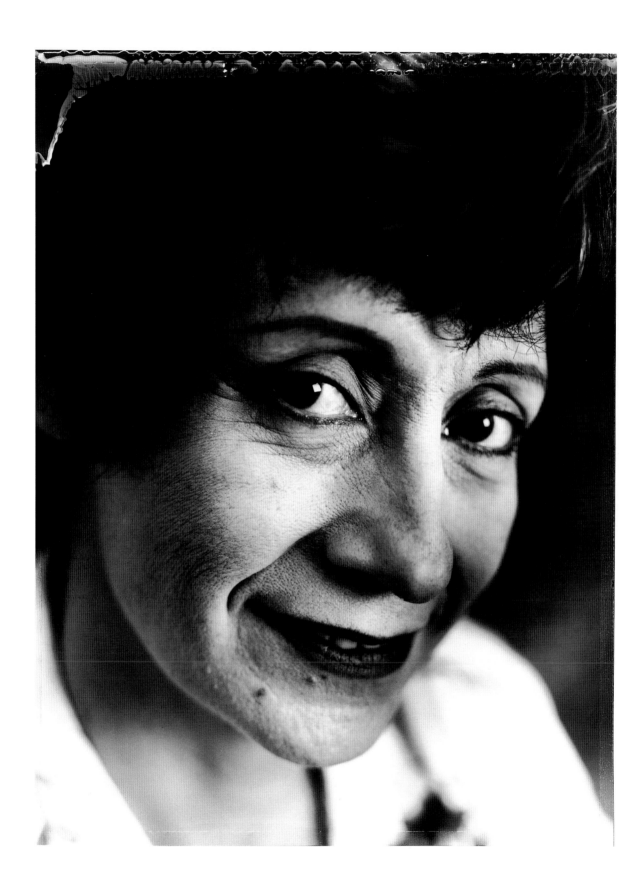

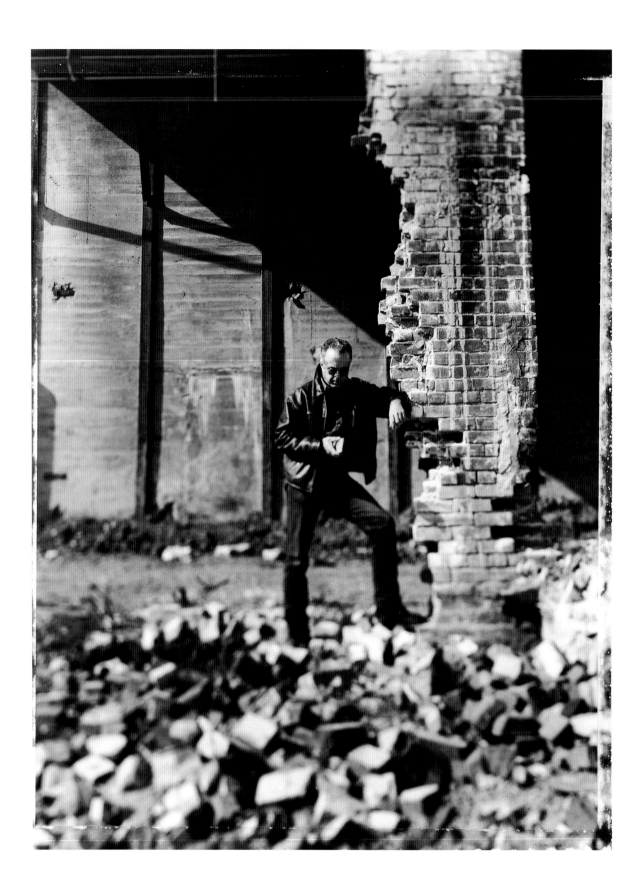

Tom Russell

"Robert Frost said life is too damn strange,
it's painful getting into, painful getting out
of . . . and the part in the middle don't
make much sense. My job, I guess, is to
put rhyme into the middle part & sing a bit
of sense into it."

December 2, 2000

I WANT TO TELL YOU 3 THINGS:

• THE WORLD IS FULL WITH MANY THINGS AND PEOPLE. DON'T EVER CONFUSE THE TWO.

• FALSE HOPE IS <u>STILL</u> HOPE.

• SOMETHING VERY WONDERFUL IS GOING TO HAPPEN. TO <u>YOU</u>.

Jon Dee Graham

"**I want to tell you 3 things:**
- The world is filled with many things and people; don't ever confuse the two.
- False hope is <u>still</u> hope.
- Something very wonderful is going to happen. To <u>you</u>."

April 28, 2006

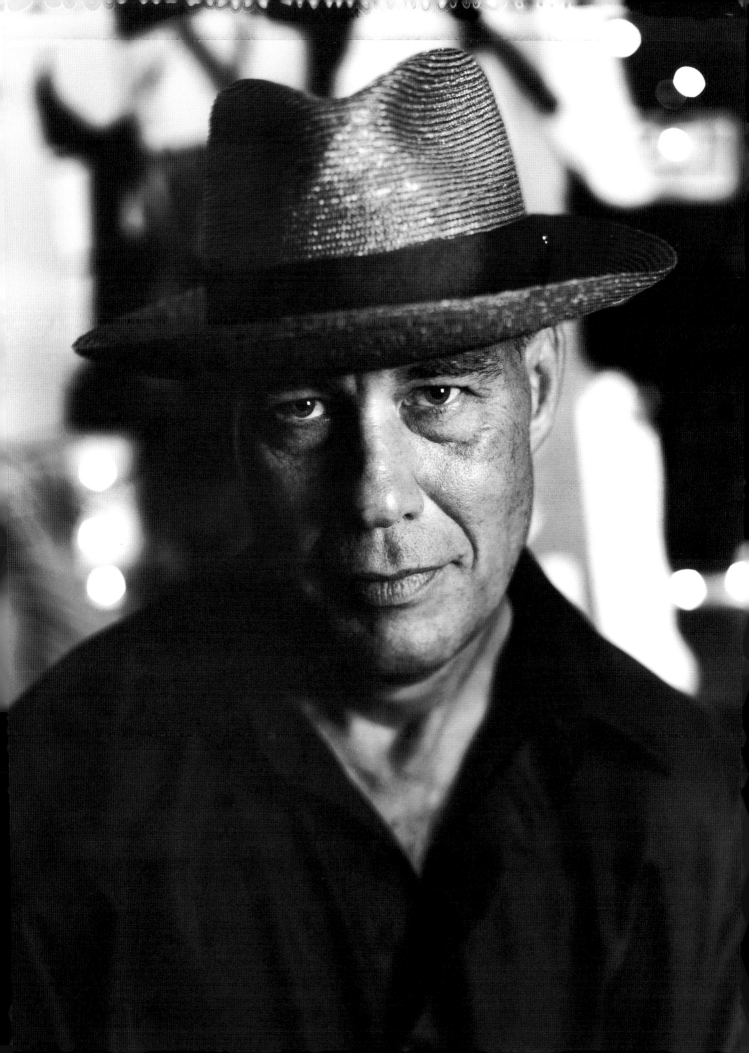

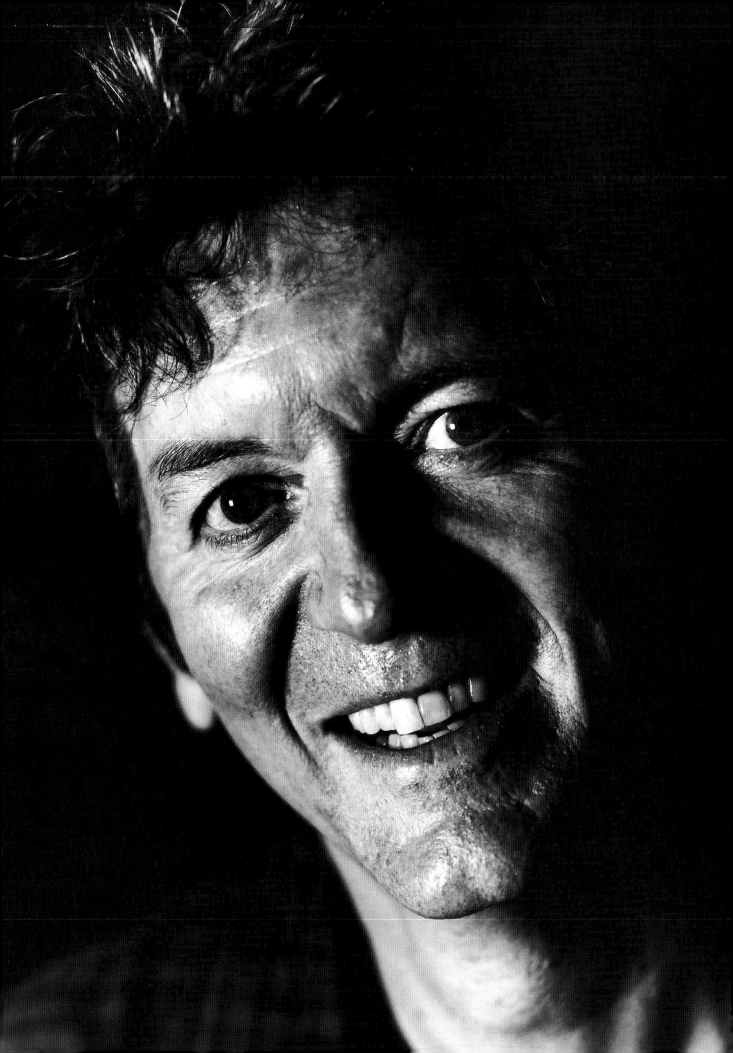

Rodney Crowell

"The thing about being from Texas is lying
with style."

September 10, 2005

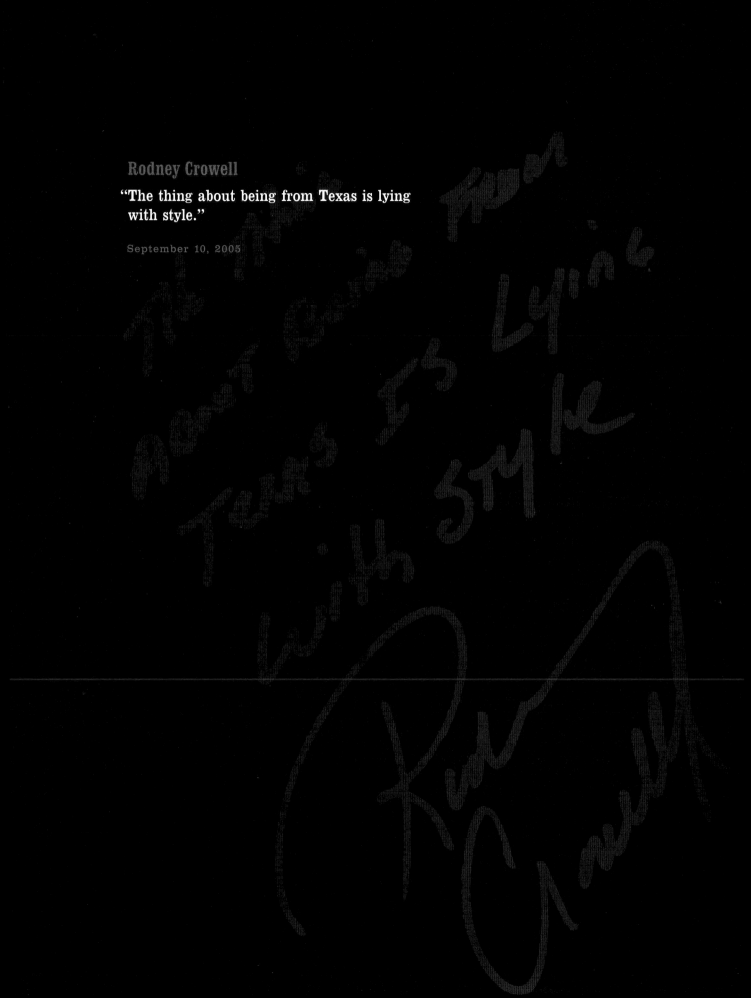

Gary P. Nunn

"There in the beginning. Have witnessed
lots. Did a little loved it a lot."

July 22, 2005

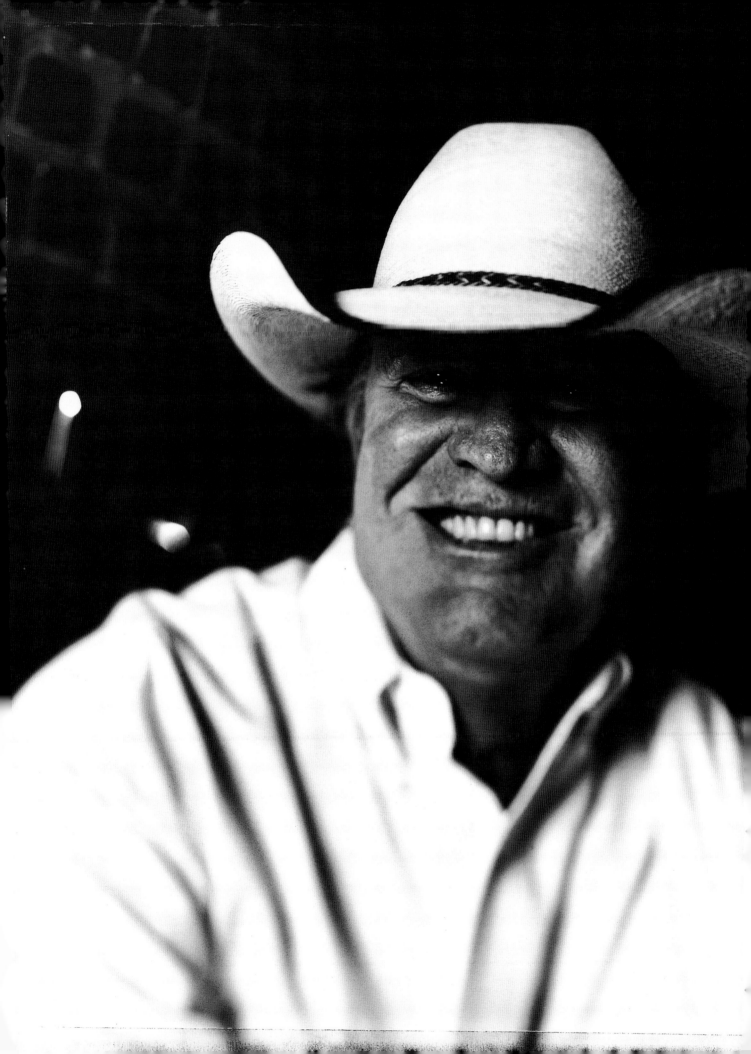

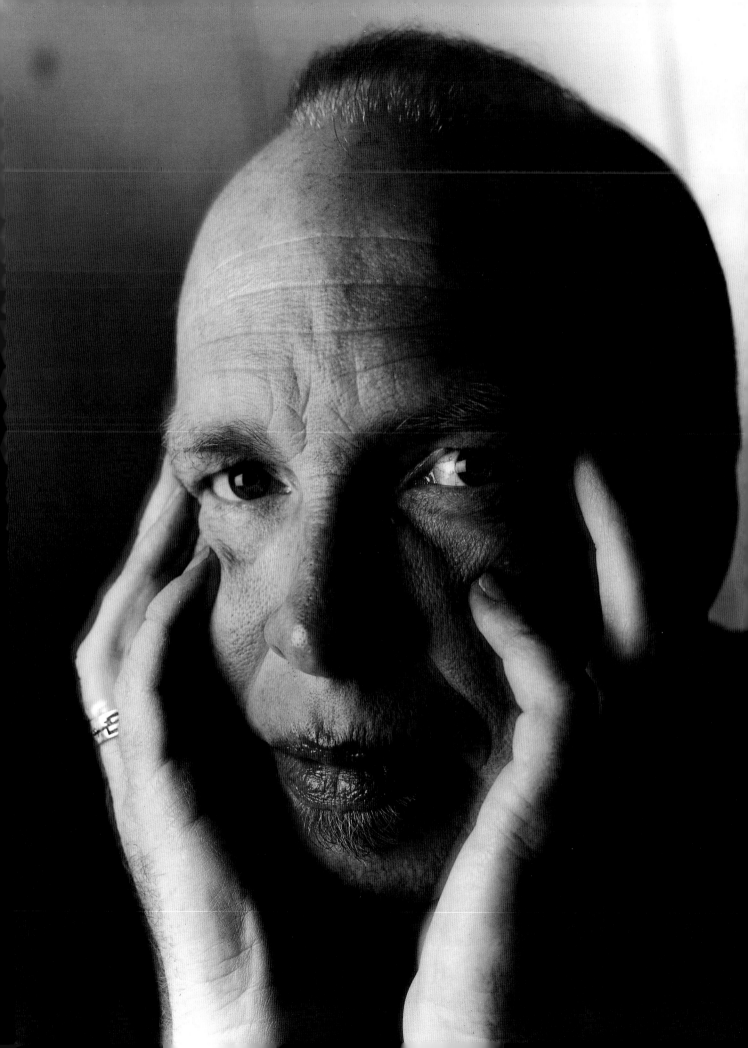

Dave Alvin, Honorary Texan

"Playing music is the closest you can get to
immortality — just a moment or two when
time stands still — the old is new — the
new is old — the dead live again —
Lightning Hopkins moves your fingers and
Hank Senior gives you the words."

April 20, 2002

THE NEW PICKERS

The portraits on the following pages portray some of Texas's newest rising stars. This group of individuals represents but a few of the folks I've had the pleasure to hear live and photograph. There could be an entire book devoted solely to musicians like this, as there is an ever-evolving group of talented individuals who play their hearts out on any given night, to ten or two hundred.

These artists are the ones who drive three or four hours, set up, play hard, and then drive home, all in a night's work . . . not always for the money, usually just for the sake of the song. They believe in the dream.

Songs
about hope
desparation
and despair
Keep me Sane!

Seth Anderson

"Songs about hope desperation and despair
keep me sane!"

February 12, 2003

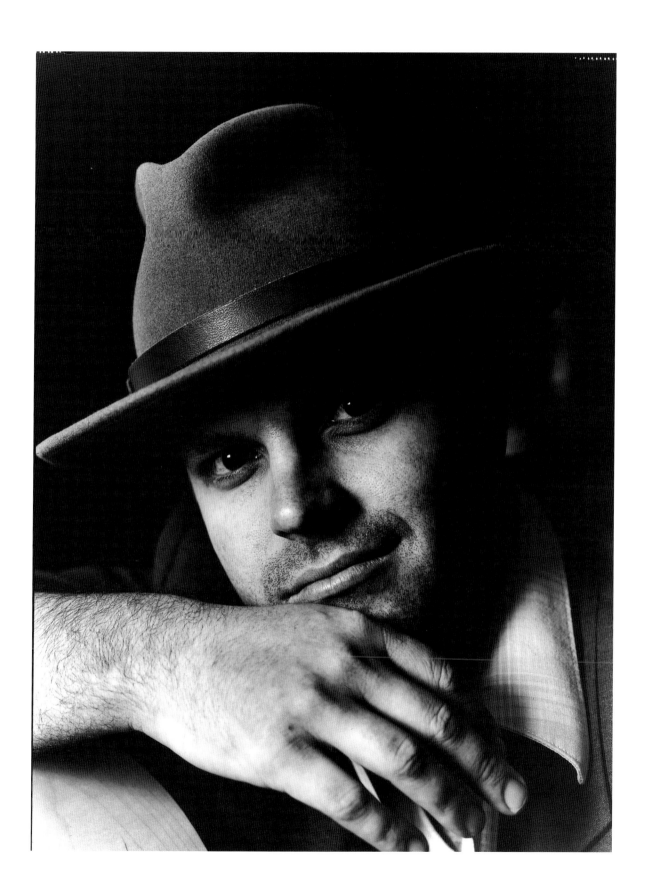

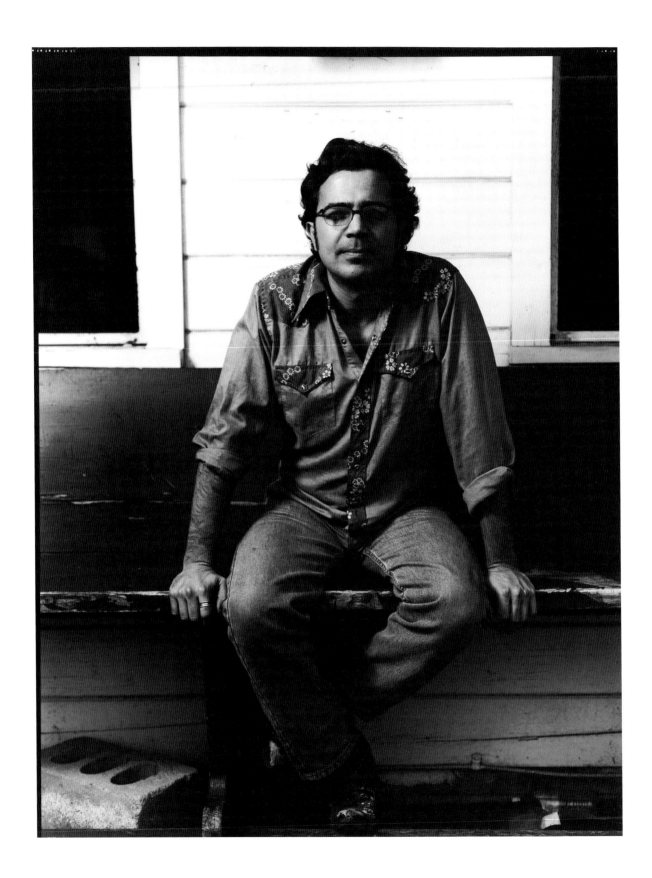

Jimmy Pizzitola

"Put your trust in the Lord and your CA$H
in a coffee can."

February 23, 2006

118

Patricia Vonne

"My music has allowed me to express myself,
travel the world, & leave something behind
. . . for this I am eternally grateful."

February 15, 2006

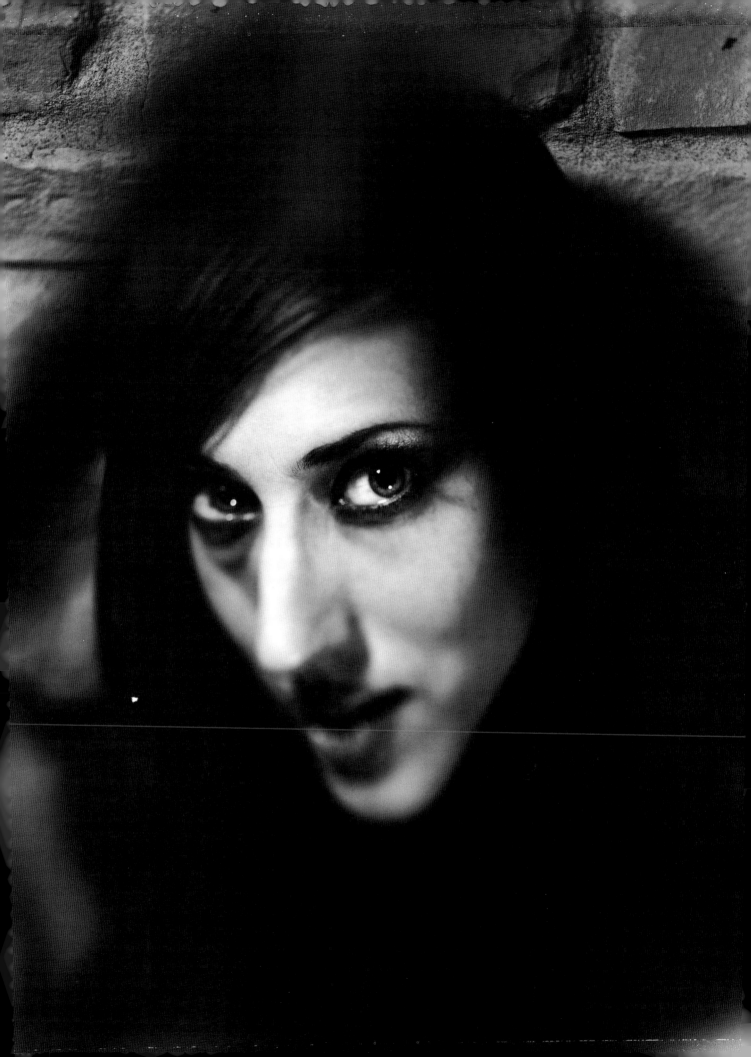

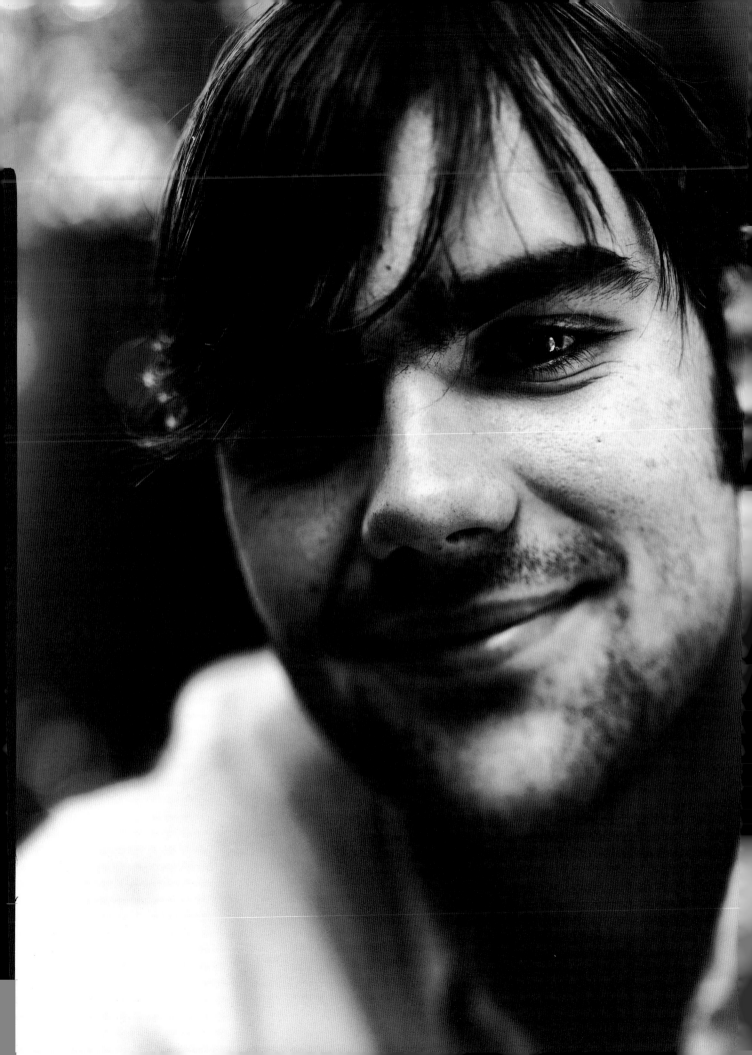

Django Walker

"Life is a roller coaster, so get in the front seat."

September 5, 2002

122

Mando Saenz

"I came, I posed, it was; and ever shall be.
Steve caught me in a good mood, if it can
be believed. Great pic. Houston in my brain."

December 12, 2001

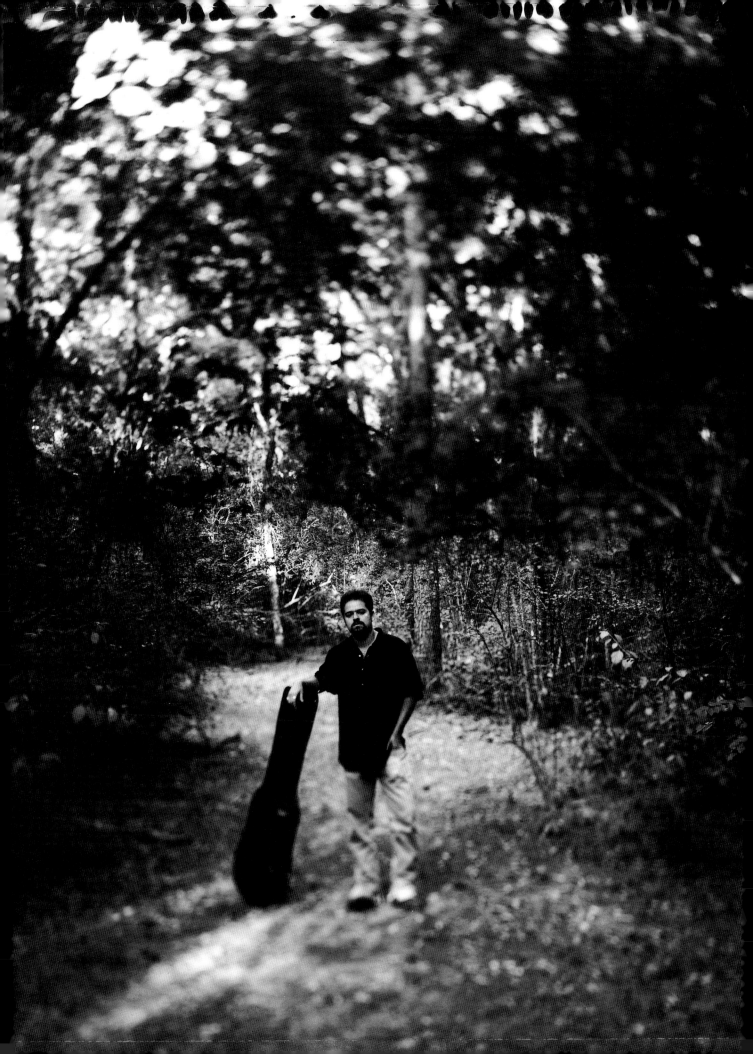

SCREW YOU,
WE'RE FROM TEXAS Ray Wylie Hubbard

I got on my cowboy boots, jeans
And Hawaiian shirt, mirrored sunglasses
And a mobile phone
I guess I look like some Port Aransas
Dope dealer that's out on bail
Just trying to get home
Well I ain't in jail and I got me a guitar
Got a little band that's hotter than a rocket
Sometimes we're sloppy
We're always loud, tonight we're just ornery
And locked in the pocket

So screw you, we're from Texas
Screw you, we're from Texas
Screw you, we're from Texas
We're from Texas baby, so screw you

Now I love the USA
And the other states
Ahh, they're OK
Texas is the place I wanna be
And I don't care if I ever go to Delaware anyway

Cause we got Stubbs, and Gruene Hall and Antone's,
and John T's Country Store
We've got Willie and Jacky Jack, Robert Earl,
Pat, Cory, Charlie and me
And so many more

So screw you, we're from Texas
Screw you, we're from Texas
Screw you, we're from Texas
We're from Texas, screw you

Now Texas has gotten a bad reputation,
Because of what happened in Dallas and Waco
And our corporations well they are corrupt
And the politicians are swindlers and loco
But when it comes to music my friend
I believe these words are as true as St. John the Revelator's
Our Mr. Vaughan was the best that there ever was
And no band was cooler than the 13th Floor Elevators

So screw you, we're from Texas
We're from Texas screw you . . .

ACKNOWLEDGMENTS

First, I would like to say thank you to Theresa May from UT Press. Her genuine excitement and confidence in me and in this project was contagious. I would like to thank all those who helped me corral the artists that I've been fortunate enough to have sit for me, even for a moment, to make this book complete. Many thanks to Pete Gordon, Crazy Mike, Trey, and the rest at the Continental Club in Houston for always allowing me to shoot at the last minute. Rusty and Theresa at the Mucky Duck, Houston. A big muchas gracias to my "ex-friend" Rick Heysqueirdo and the Lonestar Jukebox boys at KPFT radio, 90.1. Compadre Records tycoon Brad Turcotte. The Crighton Theater in Conroe, TX, Threadgill's and Cisco's in Austin, TX. The Armadillo Palace, the Alabama Icehouse, and El Pueblito in Houston. I cannot forget the crew at Anderson Fair. If not for that venue in Houston, we might not have the music that we have today.

Eternal gratitude to Tamara Saviano of Saviano Media in Nashville for having the foresight to see a good project and for making a few things happen quickly.

I'd like to say thanks to everyone who helped out by seeing my vision early on. To Buck McKinney, for letting me in the door of Rockefeller's years ago for my photography gig and for helping me through the mumbo jumbo of this *Texas Troubadours* gig. Mattie Ryf of Ryf Creative in Portland, for the initial hard work (see, I didn't forget). Mark Judson and Jeff Davis at Judson Design, Houston, for seeing beyond. Eric Hines at Mayhem Media in Denver for never saying no and pushing through with my ideas . . . and some of his own. Thanks to the Koelsch Gallery in Houston for the support and the shows! Don Glentzer gets a big one as well, for having faith in me all the way. To Kinky

Friedman for his generous and poignant prose, and for his help, along with Jason Hardioon, in trying to get to those whom I never got.

To my folks, for their support when others didn't believe. Thanks to my future "family-to-be" for all their pride and encouragement, especially Lizz Marek, whose artistic technical abilities helped me create mini-versions of the book, for when description was not enough. Neverending thanks to friends like Vlad the Impaler, who served as a keen stand-in; my assistant Chris Chance for his last-minute computer guru abilities; Mr. Barry Stiles for providing shelter from the storm; and Scott Bolin for the unending use of his hotel and his home.

Finally, I'd like to say thank you to every musician who appears in this book. If it weren't for each of you, Texas would not have its troubadours. Thank you all for the many, many years of great music.